Photographs
that
make
you
think.

D1246450

Henry Carroll

ABRAMS IMAGE, NEW YORK

CONTENTS

8

SUBLIME

YANN GROSS · CATHERINE HYLAND · SEUNGGU KIM
LAUREN HENKIN · TABITHA SOREN · CARSON LYNN
DAVID BENJAMIN SHERRY

36

TERRITORY

HENK WILDSCHUT · BARBARA ESS
HAYLEY MILLAR BAKER · ROGER EBERHARD
GOHAR DASHTI · STACY AREZOU MEHRFAR

54

MAPPING

RAHIMA GAMBO · YAN WANG PRESTON · DAN HOLDSWORTH
SYBREN VANOVERBERGHE · SOHEI NISHINO · CLEMENT VALLA

74

INNERSPACE

AWIOSKA VAN DER MOLEN · MARK MAHANEY · DELANEY ALLEN
ANNA CABRERA & ÁNGEL ALBARRÁN · BETH DOW
MICHAEL LUNDGREN · JOHAN ROSENMUNTHE

100

CONSTRUCT

THOMAS LOHR · SEBASTIAN MEJIA
NICOLAI HOWALT · URSULA SCHULZ-DORNBURG
LETHA WILSON · LAUREN MARSOLIER

120

CONSEQUENCES

ANASTASIA SAMOYLOVA · GIDEON MENDEL
AGLAIA KONRAD · MISHKA HENNER
ZHANG KECHUN · OLAFUR ELIASSON

Introduction 4
Photo Credits 142
Acknowledgments 143

INTRODUCTION

Three pounds sterling. That was how much I was willing to pay for the bag of sand. About four dollars. It was a brief negotiation, and the boy—I think his name was Will—clearly thought it was the easiest three pounds he'd ever earned. During the school break, Will and his family were flying to Israel. Israel! The farthest I had traveled as a child was the South of France. Israel, Florida, Australia, Turkey. These were faraway places experienced by other children, like Will. So, if I could not go to Israel, for a small fee, Israel could come to me. Better still, I could own a piece of it.

At that young age, I couldn't point to Israel on a map, but I had a clear mental picture of it from textbooks; I imagined it as an expanse of undulating desert under intensely blue skies. It was a place where dignified people strolled around in full-length white or black robes, even though it was unimaginably hot. And although it was an ancient land, the landscape and architecture resembled the intergalactic cities of *Star Wars*. I was, I think, vaguely aware of some contention—violent contention—surrounding Israel as a country, and the way the land had been carved up. But I had no opinion about who *should* own and occupy the land. In short, everything about the Middle East was entirely unlike the leafy and predictable landscapes of southern England, where the exchange of Israeli sand was due to take place in three weeks.

While waiting for Will's return, I wondered if he would come back changed in some way—culturally enriched and a little more worldly-wise. And, of course, I obsessed over the sand. What color would it be? Mashed-potato white? Post-it note yellow? Or a vibrant orange, like undiluted cordial?

I imagined that Will would present the sand in a Middle Eastern-style box, as if it were gold dust. I would run my fingers through its fine grains before handing over my three coins. Perhaps light would emanate from the box when opened. Perhaps the sand would sparkle as if dusted with diamonds. Perhaps it would have an aroma of spices, like the ones at the back of our kitchen cupboard that rarely got used.

When we returned to school, the only thing different about Will was the redness of his cheeks, and before I even placed my bag under the desk, he accosted me, eager for his money. It was immediately apparent that he had taken little pride in his task; hanging from his outthrust fist was a transparent plastic bag, the kind you bring a goldfish home in, and inside the bag was a handful of sand that was, I suppose, sandy in color.

All I could fixate on was the plastic bag. I wondered if it, too, had come all the way from Israel. It was such a functional way of transporting sand. The bag removed the sand's mystique. It commodified the sand—made my relationship to the sand seem completely transactional. I doubt I consciously thought these things back then, but these must have been the reasons behind my preoccupation with the bag. I felt disappointed, perhaps even a little sad for the sand, which had no doubt spent the last few thousand years being blown across deserts or pressed under the bare feet of people long dead. Throughout its existence it had been vital and precious in its own way, as simply part of the land: tiny grains that made a desert, a desert that made a landmass, a landmass that had once become the cradle of civilization. Now, because of me, the sand was contained in a transparent plastic bag, as if, like a goldfish, it owed me something.

But of course, sand—land—owes me nothing. Rather, I owe everything to land.

I honored the deal, but I have no memory of what became of the sand. I can't even remember taking it home. No doubt its grains have been absorbed into the damp soil of the English countryside. They have also found their way into the introduction of this book, which features an assortment of photographers whose images raise important questions about our relationship to land in the Anthropocene. We live in a period when our experiences of land have become very efficient, very safe, very functional, and very transactional. National parks, land ownership, industry, national borders, transportation, connectivity, photography, image sharing, tourism, and GPS are among the conventions and inventions that we accept as normal when it comes to understanding or assigning meaning to the land.

But do we really *need* such things? Do they strengthen our bond with the land, or do they accelerate the pace of our emotional detachment from it? Is it possible that, in the end, they only amount to layers of physical and mental interference between us and the natural environment? Humanity's achievements, in the course of our recent history, have ensured that for the vast majority of us, our health, quality of life, and understanding of the world have never been better. It's worth considering, however, whether our relationship to the land has also grown in sophistication. Is it possible, still, to rediscover a more primal, innate connection with the land that sustains us—to break through that "human layer," both visible and invisible, that exists between us and it? And do we even want to?

These are just some of the critical questions that the photographers included in this book have raised with their surprising imagery and experimental visual language. In relation to our encounters with the sublime, Tabitha Soren's photographs of finger marks on the glossy screens of devices suggest that nature's wrath has been reduced to risk-free visual delights. Hayley Millar Baker's use of photomontage exposes the ominous impact of colonial invasion on sacred land, whereas Rahima Gambo leaves the designated pathways of a local park only to discover

found photographs that reconnect her with her roots. Roger Eberhard, with his photographs of vanished borders, reminds us that land is never complete and always changing, and Clement Valla turns to Google Earth to show the formation of a new Earth shaped by computer glitches. While with sumptuous handcrafted techniques Anna Cabrera and Ángel Albarrán envelop us in a primordial planet, Anastasia Samoylova shows us that the future we feared has arrived (whether we choose to accept it or not), and Thomas Lohr becomes infatuated with a rock.

These photographers are, so to speak, transfixed by the transparent plastic bag that contains the sand: the "human layer." Those hungry for overly saturated photos of pristine wilderness during magic hour might find these images a little unfulfilling, a touch doomsdayish. As far as I'm concerned, they are anything but. These photographers know how futile it is to simply aestheticize land to the point of deception or self-delusion. They know that their medium of choice has a lot to answer for, that the aggressive proliferation of glossy imagery has fueled our tendency to perceive land as something to be consumed rather than cherished, something to be "clamed" by our cameras.

Nor are the photographers suggesting that we turn back the clock. We are not returning to our caves. We are not switching off the power stations, at least not anytime soon. This is a look at land as it exists today, in all its beauty and ugliness—in all *our* beauty and ugliness. We humans and our activities have, for better or worse, altered the definition of "land." There's no getting around that fact, and what's refreshing, and inspiring, about the photographers in this book is precisely that they acknowledge it. For them, land is the amalgamation of a few years of technological innovation, a few hundred years of political jostling, and a few billion years of geological upheaval. What the images in this book suggest is that it still remains to be seen which of these forces will prove most powerful when it comes to shaping the future of land—when it comes to shaping the future of humanity.

SUBLI

At around the same time I acquired my bag of sand, I had my first brush with the sublime. It was the early 1990s, when I flew F-14 Tomcats.

Unlike my brother, who would incessantly sucker-punch and butterfly-kick me with a few twitches of his joystick, I was never much of a gamer. But playing this one game, *Fighter Bomber*, would hold my attention for hours. Truth be told, I didn't actually "play" the game. All I would do is close the bedroom door, fire up my jet, and then fly alone in a straight line over a blocky, repetitive landscape of infinite green. I would pass the Matterhorn, Mount Rushmore, and the Pyramids before crashing and burning into the vast unknown; inevitably my fuel would run dry or I would be targeted by a Russian MiG. I never did learn how to fire back. Although I wasn't aware of it at the time, as a kid growing up in the urban environs of London, the landscapes in this game were as close as I could get to satisfying my innate human need to dice with the sublime. That is to say, it confronted me with aspects of

how eighteenth-century philosophers such as Edmund Burke and Immanuel Kant described the sublime: It is vast and potentially life-threatening, seemingly infinite and unfathomable, and it confronts us with a sense of our own insignificance that stirs both pain and pleasure.

Our look at landscape starts with photographers who reflect on our changing relationship with the sublime, a relationship that has seen us edge further away from real encounters. We see that over the past few hundred years, nature has largely been made safe, and our interactions with "the sublime" often amount to snapping pictures from designated viewing platforms or trails. The photographs explore how the sublime can be commodified, packaged up, and distributed, and how that leads to an emotional distancing. They look to technology and connectivity to question the psychological effects of experiencing nature's terrifying powers—tsunamis, earthquakes, and devastating wildfires—through screens. Now that we have the ability to simply switch off the sublime when it becomes too much, how does this affect our relationship with, and actions toward, nature?

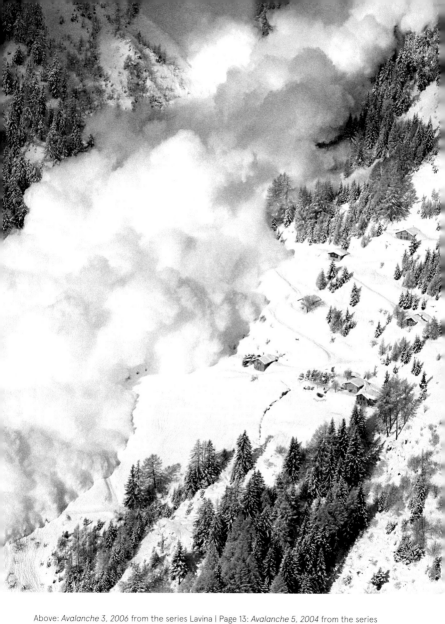

Above: *Avalanche 3, 2006* from the series Lavina | Page 13: *Avalanche 5, 2004* from the series Lavina

Should we be more frightened

if there is nothing to fear?

Mountains have developed an identity crisis. Only a few centuries ago, mountains were regarded as the very symbol of the sublime—inhospitable and incomprehensibly vast, jagged terrains of subzero peaks and unforgiving rock faces where one misplaced hand or foot was punishable by death. Now mountains have become symbols of purity and calm; they have slipped into the realm of bottled water and air freshener; they are landscapes of leisure, of ski runs where danger has been designated a color.

Yann Gross's seemingly straightforward photographs of avalanches pose complicated questions related to our command over nature's destructive powers. These avalanches are the result of controlled explosions: Accumulated snow is dynamited in order to study the dynamics of the resulting force and to make the slopes safe for skiers and for those staying in resorts. In this respect, the avalanches have been neutralized

to a certain extent—their destructive force saves lives rather than taking them. And because this unleashing of power is scheduled to the second, Gross was able to take up position on the opposite slope, ready his composition, and then appreciate this awesome event in entirely aesthetic terms, knowing there was no threat to his life or anyone else's.

Without a horizon, space becomes flattened and our initial reading of scale hard to define. Silenced, stilled, and reduced in size, the sublime becomes contained by the image. This tsunami of snow is abstracted; it is going nowhere, and its mass appears intangible, like a cumulus cloud that could simply drift on by. That is what is so striking about Gross's photographs: the matter-of-factness of it all, the slippage from fear into fascination. They represent not just nature but human nature and our desire to conquer what we fear. However, one has to wonder what will become of us and how we will relate to nature when everything has been made safe.

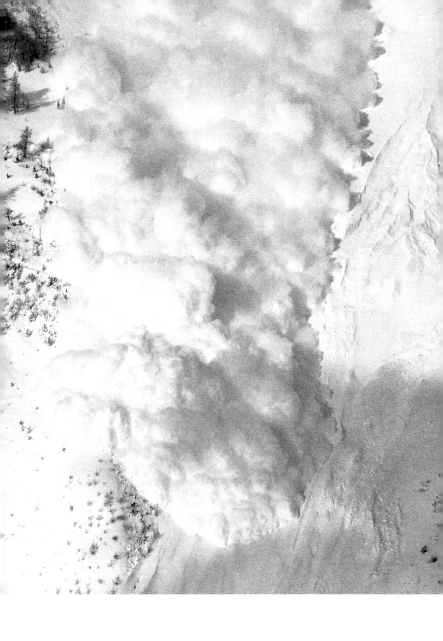

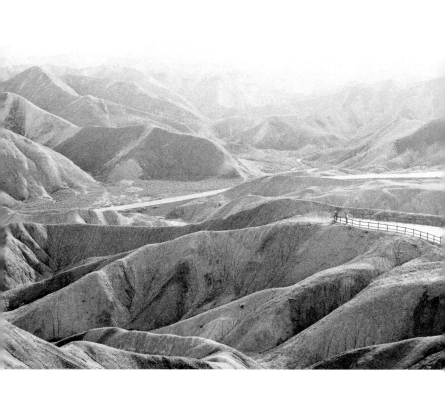

Universal Experience, 2017

The vastness of it all. That is what hits you first when you look at Catherine Hyland's photographs of China and Mongolia. Then you see the people, so tiny, so insignificant in comparison; yet

What does landscape owe you?

no matter how small they appear, once spotted, their presence is impossible to ignore. In this image, swirling rock formations undulate through the composition, gradually vanishing into the haze. Though the landscape is dry, barren, and inhospitable, it clearly poses no threat to the two people standing on the nicely paved platform behind that neat little fence. One wonders what drew them to this end of the road in the middle of nowhere. As impressive as the view might be, surely it cannot be the only reason.

Unlike the people in her images, Hyland does not place herself in the primo position, the place where one is told to stand in order to gaze at the landscape. Instead, she takes a step back to draw our attention to the structures, both physical and mental, that shape our interactions with landscape. Places that should be "awe-inspiring" appear a little out of emotional reach. Walkways snake up and down ridges, and peaks have been flattened for convenience. Even the haze appears more like a mental state than like an atmospheric condition, lending Hyland's images a slightly washed-out quality that denies us the overly saturated splendor of the sublime. These vast, remote landscapes look a little gaunt, a little short on spiritual substance and satisfaction. Have the disparate people strolling along the pathways received what they came for? And what was that, exactly—authenticity, nourishment, escape? Hyland's photographs present a picture of opposition and unity, the coming together of humans and landscape and their total misalignment.

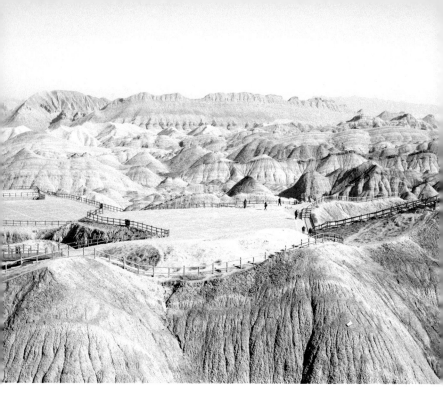

Above: *Universal Experience, III*, 2017
Opposite: *Born From Sea Foam, VII*, 2021

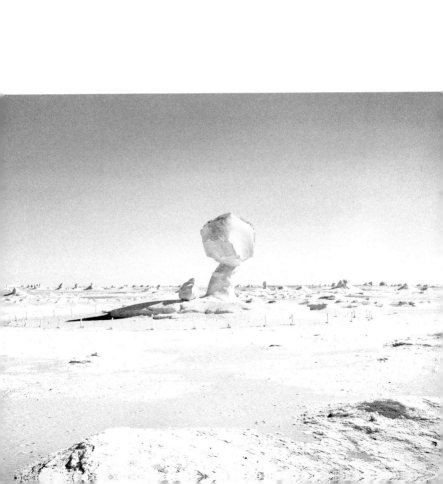

Can the
s u b l i m e
be re-created?

You are looking at Mount Geumgang: Its summit is more than
five thousand feet high, and its rocks emit energy that brings
life to the world. At least, the real mountain in North Korea
does. This is a replica, made of Styrofoam and decorated with
rocks and plants, and it rises up from an exclusive apartment
complex in the South Korean city of Seoul. Seunggu Kim has
been photographing this "mountain," and others like it, for
years, devoting to it the same time and respect he would to the
actual mountain. We see this formation in different seasons
and lighting conditions. Here the flowers are bountiful, and the
flowing waters are pictured as a blur of tranquility, thanks to the
healing powers of a slow shutter speed.

In other images, the distinctive peaks are covered with
snow or pictured during the magic hour. These changes in
appearance are part of an urban landscaping trend in South
Korea known as *jingyeong sansu*, which is intended to provide
the nature-starved residents of Seoul with the spiritual payoffs

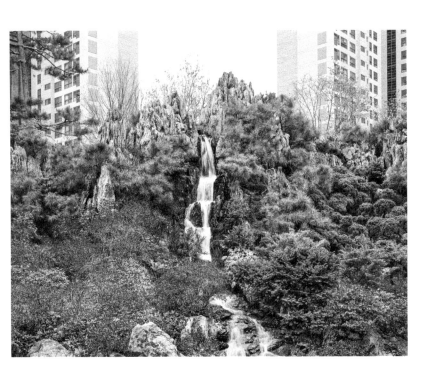

Above: *Mt. Geumgang 3*, Seoul, May 2017
Following spread: *Mt. Geumgang 1*, Seoul, January 2011

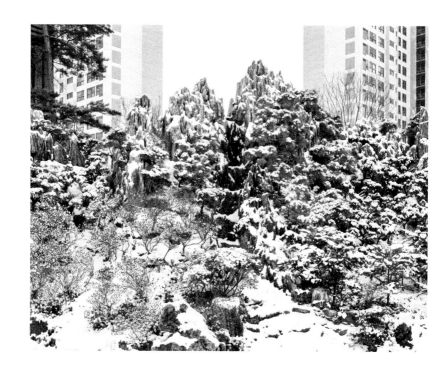

of actual nature, including the sacred mountain on which this one is based, which happens to lie in a country they cannot visit. In Kim's images, we see how the sublime has been commod-ified, replicated, and miniaturized, but we also see how this capitalistic interpretation of natural splendor is not entirely inauthentic. While this mountain presumably does not emit any "energy," it still casts some kind of spell on people, and seeing it respectfully pictured over time imbues it with significance, with its own life and history. In many ways, it is no different from other places of worship—churches and temples designed to provide spiritual nourishment, demanding only a brief commute to communion. This may not be the real mountain, but Kim's photographs suggest that in the Anthropocene, we no longer acknowledge the difference between what is natural and what is artificial. If a sacred mountain is too inconvenient, too inaccessible, we'll just re-create it. And if we want it to be significant, if we require it to be special, then it will be.

From the series Second Nature, 2015

Does technology make you feel

more or less

connected to nature?

At first glance it looks like any other snapshot taken from the well-trodden viewpoint overlooking Yosemite National Park. Then, on closer inspection, the image starts to break apart; building blocks of red, green, and blue become more obvious. Is that a cursor lingering below the waterfall? This photograph of an onscreen photograph is from Lauren Henkin's series Second Nature, for which her starting point was a somewhat prophetic statement written by Susan Sontag in her 1977 book On Photography: "Photographs," Sontag wrote, "have increased our access to knowledge and experiences of history and faraway places, but the images may replace direct experience and limit reality."

Henkin's image suggests just this when it comes to the sublime. Photography and technology have rendered our encounters with such landscapes commonplace. We are able to hold mountains and deserts in the palms of our hands. If we are considering a trip to the Alps or the Sahara, we can zoom into the peaks, walk our fingers across the sand dunes, and flick through the thousands of photographs already taken by others before thinking, Meh. This easy access to everywhere does, indeed, reduce our desire or even our need for nature, and thus fuels a state of emotional distancing. Hardly surprising that we so willingly exploit, abuse, and destroy the planet if we so often experience and engage with nature through its opposite, technology.

Unlike the very inactive landscape on the previous spread, here a wildfire rages, the sky is choked with smoke, and the trees are burned and black. Gestural marks of vivid purple that look like brushstrokes at first appear to be whipping this devastating scene into an even more ferocious storm. The ghostly flecks of color in Tabitha Soren's image are, in fact, the grease marks of fingers left on a touchscreen device. In other images from her series Surface Tension, similar finger marks obscure and interact with cathedral-size icebergs and tornadoes ripping through fields. The images are seductive, both beautiful and violent, and contain a disturbing duality.

What do you feel when you see scenes of devastation on your phone?

Traces of gestures that look impassioned, the result of some kind of desperate attempt at intervention, might also suggest passive engagement; someone swiping their screens, half engaged, while watching Netflix, perhaps. By showing evidence of a physical connection (i.e., skin on screen), Soren draws our attention to our emotional disconnection from what we see through the glass. At certain times of the year, scenes of devastation, whether floods, hurricanes, or fires, fill our feeds before being drowned out by whatever else is in the news. Backlit and glossy, the devastation contained within these images becomes, to a certain extent, mesmerizing. Repost and share, like and comment. Now everyone can experience the sublime power of nature in the palm of their hand.

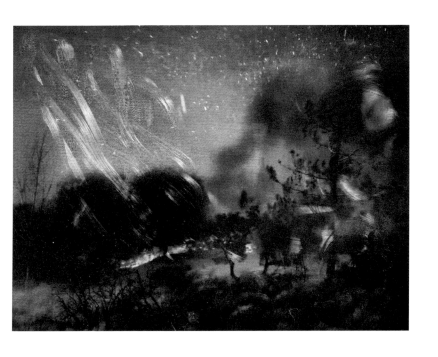

Above: *flickr.com/photos/usforestservice/45912334351/in/photolist*, 2019
Following spread: *Katie's Vacation Photo*, 2018

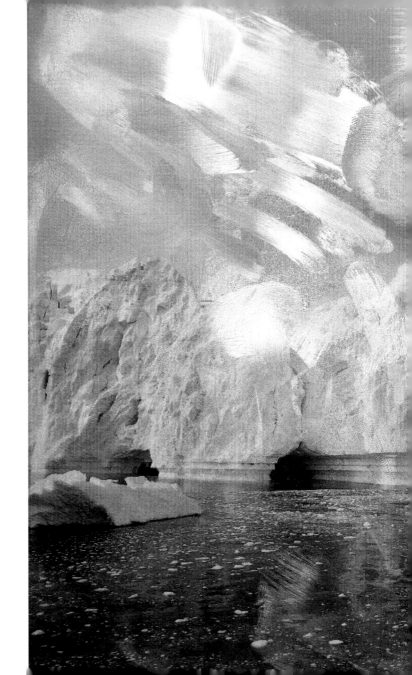

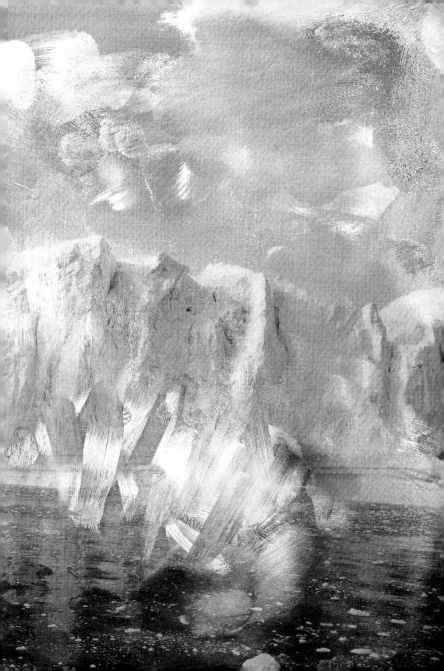

**CARSON
LYNN**

If we live in a simulation,

It has become a fashionable philosophy to claim that we are all living in a simulation where everything that occurs, and what is and isn't possible, has been programmed and predetermined by a more advanced civilization. If this is the case, when I find myself exploring another simulation, this one created by Carson Lynn, I can't help feeling like the "real world," the one that has supposedly been designed for us, is a little underwhelming. Why isn't Everest even higher? Why isn't Niagara Falls five times as deep?

why isn't everything a bit more "wow"?

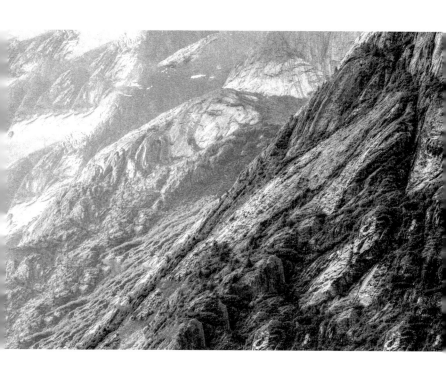

Above and following page: *Walking Simulator, Game Screenshot*, 2016

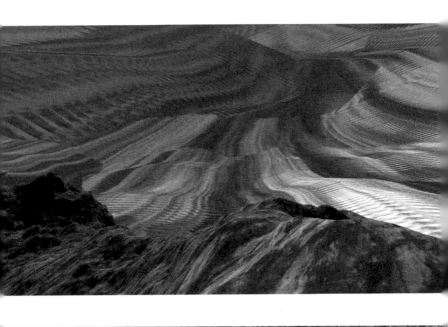

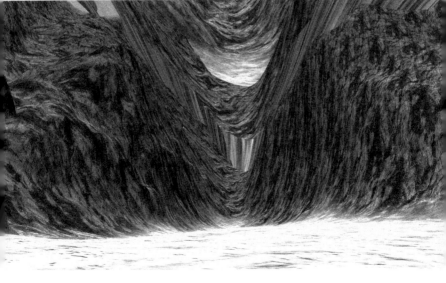

Lynn bases his world on video games known as "walking simulators," which see players roaming alone through seemingly limitless landscapes that still largely conform to the bounds of reality. Lynn, however, draws attention to the virtuality of his world by exploiting a common programming glitch. The sky in such games is created using a "skybox." Because Lynn has omitted the skybox from his programming, the terrain becomes multiplied in empty space, locking the player into an impossibly infinite landscape. One wanders through canyons where the walls have no rims, across meadows where blades of grass slice up the sky, and along ridges that unfold into patchworks of peaks. In these virtual landscapes, one feels a sense of genuine isolation and envelopment, perhaps even a touch of loneliness and insignificance.

Rather than strive to win or achieve anything at all, we journey ever deeper, simply finding ourselves enjoying these sensations because our experience of actual land-scapes—undertaken in the company of others and restricted to designated paths and roads—frequently fails to deliver such responses. The continued taming of the real world, whether it's a simulation or not, makes you wonder whether our future encounters with the sublime are destined to take place in virtual worlds such as Lynn's, worlds where anything—pain, dread, and perhaps even death—is possible.

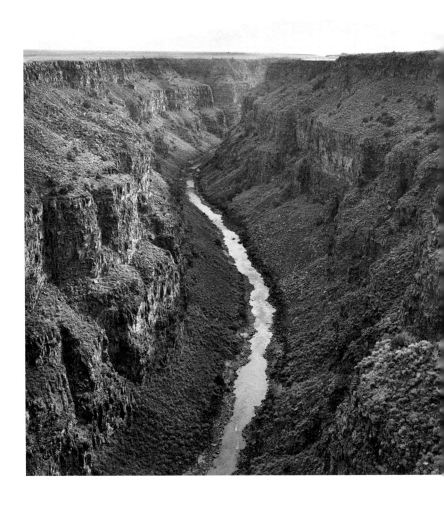

Above: *Rio Grande Gorge, Rio Grande del Norte National Monument,* New Mexico, 2017
Following spread: *Wahweap Hoodoos II, Grand Staircase-Escalante National Monument, Utah,* 2019

Expeditions into the unknown; bloody battles with Indigenous peoples; conquest, ownership, and exploitation. The notion of risking life and limb to tame wild lands goes hand in hand with traditional notions of masculinity, and capturing such places in pictures has been very much the reserve of the straight white male gaze. Even today, our mental image of the great American West is formed by the stately black-and-white photographs of Timothy H. O'Sullivan, William Henry Jackson, Ansel Adams, and Edward Weston.

Whose American West is it?

David Benjamin Sherry follows in the photographic traditions of these men, working in remote locations with a large-format camera and then utilizing painstaking darkroom techniques. But his depiction of the West could not be more different from theirs. The colors in Sherry's photographs, peppy and upbeat, imply a different kind of adventurous spirit—one of playfulness, fantasy, and liberation that's more in line with his own identity as a queer man. Vivid pinks, purples, and yellows transform these vast landscapes and jolt us into reevaluating our relationship to the American West. By not seeming beholden to traditional photographic representation, Sherry's landscapes appear more approachable, more available to those who might previously have felt excluded from the great outdoors.

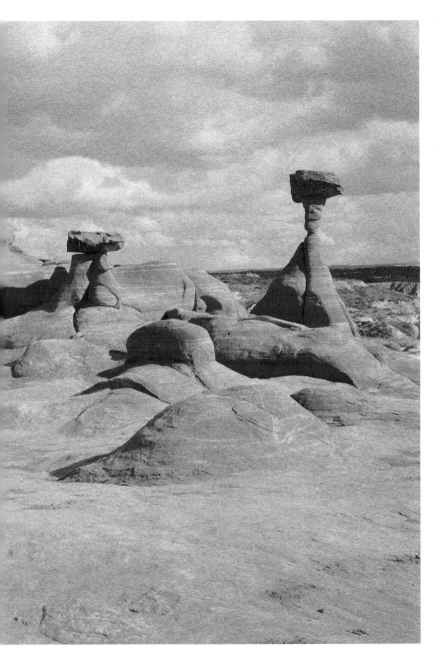

TERR

When we lived a nomadic, hunter-gatherer existence, which is about 99 percent of our human history, it's widely assumed that we had no clear concept of "ownership," let alone land ownership. While we did hold vague notions of territory, the land we roamed was shared, and its limits were defined by mountain ranges, rivers, and shorelines rather than artificial boundaries. About twelve thousand years ago, a shift toward agriculture tied us to specific patches of earth, which sowed the seeds of land "ownership" and control. Perhaps it's no coincidence that around that time a fight broke out on the banks of a resource-rich, fertile lagoon called Nataruk in East Africa. The skeletal remains of twenty-seven people, including six children, mark the earliest evidence of violent conflict between humans. Over the next few thousand years our dependence on specific areas of land became more entrenched. Various economies and social systems emerged, and vague and shifting territorial boundaries have been increasingly drawn in blood.

Over the last decade, following the highly visible mass migrations into Europe and the United States by those fleeing conflict and poverty, photographers have become increasingly concerned with the concepts of land ownership and borders. The work in the following pages explores how national identity and patriotism have become weaponized by politicians, and how leisure habits, religion, and the unclaimed reaches of space have affected our attitudes toward land and our access to it. While our image of borders is often formed by the increasing number of human-made walls, this work serves as a reminder that "territory" is as much a mental construct as a physical one.

ITORY

While documenting the refugee camps in Tunisia, France, and Jordan, Henk Wildschut noticed that some residents demarcated their plots from the rows upon rows of other tents by creating fenced-in gardens. He saw that residents used whatever materials were at hand to build such barriers and devised rudimentary irrigation systems using plastic bottles to grow plants. The tents in such camps are largely the same—standard issue from the

Are borders a basic human need?

United Nations Refugee Agency—but the one in this photograph has been personalized. The creation of a clear boundary line gives this temporary structure a feeling of permanence, and there is no question that the occupants are exercising a form of ownership and control over the modest plot.

In one sense, these gardens are a wonderful expression of dignity and resilience. They illustrate the very human need to feel secure even in the most chaotic and unpredictable situations. Yet many of the occupants of these tents were forced to flee their homes due to religious and political con-flicts sparked by the demarcation of land, and here, on a micro level, is just another example of land ownership. With his series Rooted, a title that intentionally plays with the concept of one's attachment to land, Wildschut reflects on our seemingly instinctive desire to establish physical boundaries. While these gardens are benign, something for their owners to care for and nurture, the marking of boundaries speaks to our fundamental and problematic relationship to land. One that results, time and again, in so much suffering.

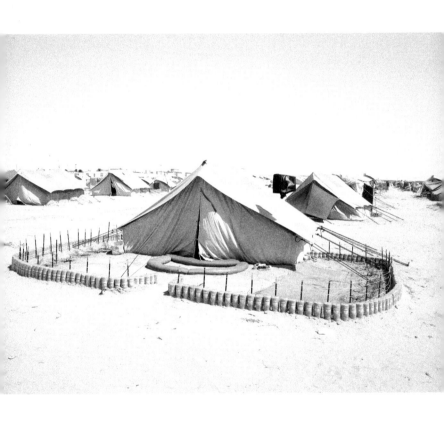

Choucha Camp, Tunisia, July 2011

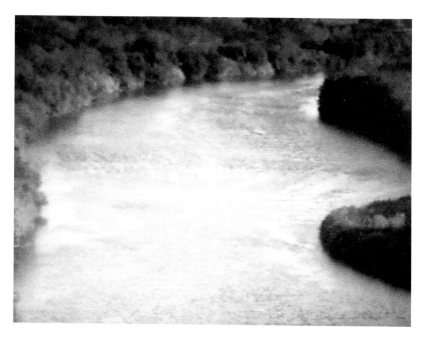

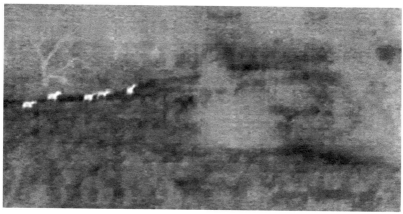

Top: *Rio Grande*, 2012/2019
Bottom: *Wild Horses [Surveillance Series]*, 2010

Is a nation's gaze a kind of border wall?

From her New York City apartment, Barbara Ess gazed at her computer screen, transfixed by activities taking place in pixelated landscapes thousands of miles away on the U.S.-Mexico border. The network of low-resolution and heat-sensitive cameras that Ess tuned into were installed to help a disparate community of ever-vigilant U.S. citizens monitor and report illegal border crossings. Ess, however, was not concerned with reporting anything she happened to see to the authorities. Instead, viewing these live feeds from the comfort of her apartment stirred a peculiar state of physical and psychological distancing for Ess, allowing her to appreciate them for their unintentional aesthetic sensibilities.

While real and viewed live, the landscapes felt almost imaginary and totally disconnected from the corner of the country she occupied. Ess would take screenshots of subjects that caught her eye—wild horses, reflections of trees in rivers, and the lush green banks of the Rio Grande. Her resulting images are painterly and contain hints of the romance found in works by the Hudson River School and other historical paintings of the American West. By usurping the intention of these malevolent all-seeing eyes, Ess manages to shake off or reframe the intensely political and aggressive gaze of the cameras and rediscovers the natural beauty, or freedom, of a border landscape that has become associated with violence and division.

Using collaged elements that represent her own Aboriginal heritage, along with symbols of Christianity, Hayley Millar Baker pieces together a jagged picture of Australian landscape. Unlike the British invaders of 1788, the Aboriginal population does not perceive landscape as something to be defined by fixed borders and ownership. They value the land for its sacred significance. The land is not there to be "owned." If anything, Aboriginal people believe that the land owns them.

Whose land are you on right now?

The stark horizontal division in this image creates a narrative that confronts these two different perceptions of territory. Starting at the top, "creator beings" such as eagles soar over lush hills and a young girl, the artist's mother, surveys the vista from the top of a sacred rock. As our eyes wander down the image's strata, emus walk over an outcrop that descends into rubble before a strip of sky marks the transition into another reality, a border within the image itself. This new landscape is dominated by a church, an image of colonial religion that became an icon of fear and suffering for many Indigenous peoples. Indeed, its sharp architecture against bare trees makes it appear ominous and threatening; never has the sight of an Easter bunny felt so malignant. In Millar Baker's patchwork portrait of a nation, one feels the brooding tension of two very different worlds vying for position on the same land.

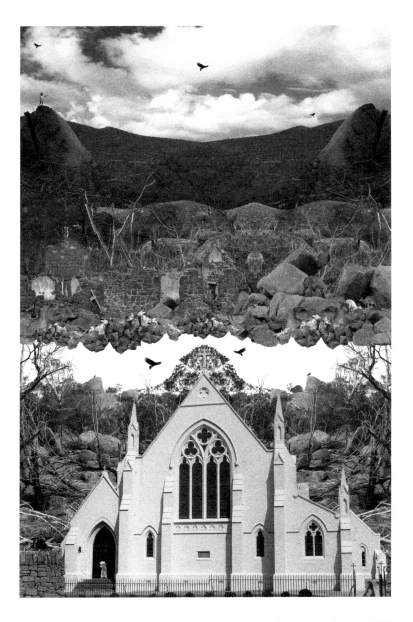

Even if the race is fated to disappear 1 (Peeneeyt Meerreeng / Before, Now, Tomorrow), 2017

24th Parallel South, Chile, 2018

Are you
comforted or concerned
by the impermanent nature of borders?

It was, perhaps, a touch counterintuitive for Roger Eberhard to travel the globe in search of subjects that no longer existed. Unsurprisingly, his resulting photographs often lack an obvious focal point, yet we must trust that there was a specific reason for the photographer's eye to fixate on a corn field in Belarus, a bend in the Yellow River, a dusty road in the southern United States, or, as is the case here, a patch of the Atacama Desert. Eberhard's locations are, or were, the locations of borders that have been moved, erased, or forgotten.

This landscape was the site of a border between Bolivia and Chile until war broke out in 1879, a war that saw Chile extending its territory several miles into another country's dominion. Whatever meaning or significance this landscape once had, whatever attention it demanded due to a contested political boundary, has vanished, from sight at least, but perhaps not minds. This unseen aspect of Eberhard's images contains a universal truth about territory. The imposition of borders, their walls and armed guards, implies that the way land is divided up now is the endgame—the way things are supposed to be. Yet no human-made border has remained, or ever will remain, unchanged forever. The shapes of nations are constantly shifting, whether on account of conflict, political will, or climate change. The subjects that Eberhard was searching for do most definitely exist, but only in memory; photography's inability to record what can no longer be seen does, in fact, expose all. The present always becomes the past, and, when left alone, land itself has no interest in preserving the legacy of humans, especially the imposition of our politics.

It is like a portal within the landscape, a sharply defined rectangular window that you could step through. But where is our destination, as both landscapes look and feel similar? Perhaps if we were to turn around, the scene within the scene would be there in reality. In Land/s, Gohar Dashti photographed landscapes of the United States, printed them as large as life, mounted them on boards, and then installed them in various landscapes of her home country of Iran. For Dashti, who now lives in the United States, certain landscapes, certain encounters with nature, reminded her of home. Nature became a way to feel connected to her roots, a way to reconcile physical distance and political division.

Where does a landscape begin and end?

Her technique of mounting images on large boards blends and disrupts the continuity of the landscapes. In some images, Dashti positions her boards to draw attention to their physicality, to create an imposition in the landscape. Their angle to the camera reveals their materiality and shadows that defy the contours of the landscape pictured cut across them. At other times, the U.S. landscape almost entirely merges with the dense vegetation of Iran, only certain edges of the frame making themselves visible. When we look at Dashti's composite images, our attention is drawn to the curious differences and striking similarities between the landscapes. Neither view meets our preconceptions about what the United States or Iran looks like. Each is varied and nuanced, each a complex system of identities. As such, Dashti's works both overcome division and reinforce it. They present us with the possibilities of unspoiled nature, terrains untouched by human hands, while at the same time the clear lines that demark the images within the images acknowledge the constructed, carved-up nature of the planet.

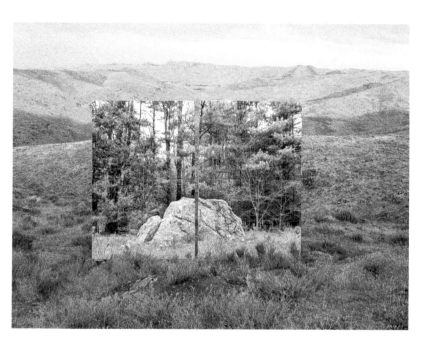

Untitled from the series Land/s, 2019

Above and opposite: Untitled from the series Land/s, 2019

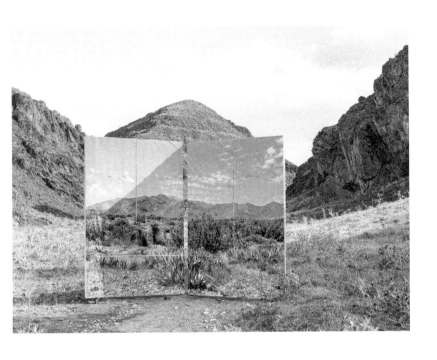

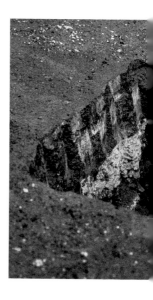

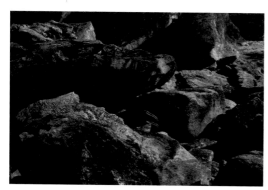

Above and following spread: From the series The Moon Belongs to Everyone, 2014–20

How does landscape inform your identity?

The compositions fixate on the nondescript. These patches of dry earth, dense branches, layers of rock and tangles of long grass could be found in almost any part of the world. Are these places close to each other or thousands of miles apart? Our point of view is continually blocked by vegetation, shadow or a shallow focus. It's as if the photographer, Stacy Mehrfar, is searching for something in the these places, expecting to find clarity or specificity, a sense of connection with what is around her. Close up portraits of anonymous people of ambiguous ethnicities interrupt the landscapes. They, too, appear out of context. Rather than be *somewhere*, it feels like they are nowhere. They occupy a state of limbo. If it is possible to photograph what is inside someone's mind, here the thoughts seems to be, "where am I?" or "where should I be?"

Like her subjects, Mehrfar is a native of one country and a settler in another. In a way, she has three identities, one tied to America, where she was born, another tied to Australia, where she emigrated, and another tied to Iran, where her family is from but she has never lived. In this work titled *The Moon Belongs to Everyone*, Mehrfar blurs the rigidity of national borders to probe the psychology of relocation, of being an immigrant, and the amorphous self-identities that result. Here we can read the landscapes as less physical locations and more mental projections. Tangible and intangible people and places shifting from the present to the past, from reality to memory. Clarity and specificity do exist in Mehrfar's self-contained universe. She shows us that we are an amalgamation of everywhere and everyone, that we are not defined by the landscape around us, but the landscape within.

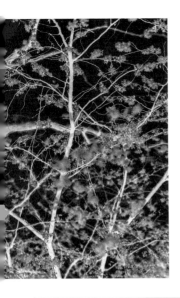

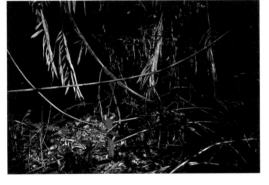

On Google Maps, the sprawling urban areas of Los Angeles are depicted as shades of light, uninspiring gray, while the nearby San Bernardino National Forest is in shades of enticing, textured green. There was no particular reason for me to drive to the forest that weekend. I just felt the need to take a day trip. I suppose I wanted to escape the gray. Turning off the I-10, I followed an ascending mountain road that I would describe as rural, definitely not urban. Yet looking at the GPS, I was still surrounded by gray. It was almost as if the map, not my eyes, was telling me what to make of my surroundings. This continued for another seven miles until, all of a sudden, I crossed into the green. I saw this transition coming on the screen, which made it feel more profound than it was, because somewhat disappointingly, nothing about the surrounding landscape had changed; all around, dusty ground was dotted with parched, shin-high brush. The only physical feature that acknowledged my transition from one "landscape" to another was a large wooden sign that read, "SAN BERNARDINO National Forest."

MAPPING

As commonplace as it is, this little anecdote illustrates the divide between represented landscape—in this case a map—and reality. Though nefarious intentions are not always at play, visual representations of land are rife with social, economic, and political agendas. These agendas are designed to control movements and shape opinions about which physical features are and are not significant. In recent years, maps have become so detailed, so sophisticated, that they not only represent landscape, they replace it to a certain extent. Three thousand years ago, maps were vague, inaccurate visualizations of a largely undiscovered world, and exploration was the name of the game. Now, we can experience the entirety of the world's surface within the map itself. GPS, not landmarks, tells us which way to turn; Google Street View allows us to arrive at our destination before leaving home; and no matter how far we journey, that little blue dot always places us in the center. This new virtual world, quite literally, revolves around us.

The photographers in this section explore the space between real and represented landscape. They expose the conventions that promise freedom while providing a closed network of experiences through physical and algorithmic pathways. Their work ponders whether it is a good thing to always know where we are; the value, power, and influence that come with obsessively mapping every corner of the planet; and at what point the detail and interactivity of a map cause it to become an entirely new world. In an attempt to reconnect with land, the photographers create their own systems of cataloging and organizing to discover a greater sense of self and place.

For many of us, a walk in the park is our only regular encounter with nature. To reduce urbanites' anxieties about being confronted with open space, maps appear by entrance gates, detailing various routes that will enhance, or control, your experience of nature: *This path will take you to the duck pond, that one to the picnic area. Please do not step off your chosen path or your experience of nature will become unpredictable and inefficient.*

Who created the paths you tread?

Stepping off the path was exactly what Rahima Gambo did, looking to reconnect with her hometown of Abuja, Nigeria, after years of work-related travel. By venturing into the wilder areas of Abuja's Millennium Park, Gambo discovered her own points of significance: a yellow leaf, a freshly fallen seed, tree trunks twisting through lush green. Over time, Gambo started collecting offerings from the park, both organic and inorganic, such as plant cuttings and torn-up photographs found in the undergrowth. Some of the photographs had clearly been discarded due to printing flaws, while others were imbued with more violent intent.

Gambo placed natural elements over the photographs and sketched plants growing between the image fragments, the lines of the tears and the colors of the mounts echoing those of nearby foliage. It was a process that allowed her personal history and the histories of strangers to coexist in a specific place and time. Ultimately, by ignoring the designated routes that control our experiences of nature, both physical and mental, Gambo transformed a park into "her park." It became a personal, private landscape that regrafted her to her roots.

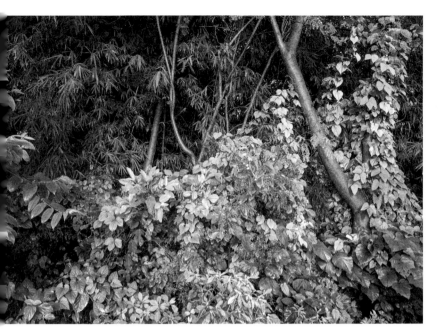

Top: *A Walk Landscape V, Abuja,* 2018
Bottom left: *A Walk Collage IV*, 2018
Bottom right: *A Walk Collage II*, 2018

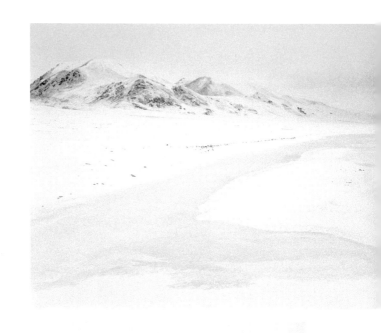

Top: *Y2_100km from the river source*, from the series Mother River, 2010–14
Bottom: *Y58_5,700km from the river source*, from the series Mother River, 2010–14

*Divide the entire Yangtze River into 62 sections of 100 km each.
Starting at the source of the river and ending at the mouth, pho-
tograph the 63 dividing points of the sections with a large-format*

What
turns land
into landmark?

camera, whatever the terrain and no
matter the cost. That was the system
Yan Wang Preston came up with to
photograph the third-longest river on
earth. The resulting sixty-three images,
captured over four years, take us on a
meandering journey from the pristine

frozen wilderness of the Tibetan Plateau to the industrial low-
lands of Shanghai. In some photographs made near the source
of the river, the landscape appeared to have offered Preston no
shortage of epic vistas to work with at the designated spots. As
Preston traveled downstream, the gradual increase of industry
presented opportunities that are less majestic or classically
beautiful, but that serve to complete the river's story.

A foreground construction site, for instance, is con-
trasted with history as the graceful lines of a pagoda can be
seen through the haze of pollution. By following such a rigid,
self-imposed framework, one where she did not know what
subject matter would be encountered at her predetermined
coordinates, Preston produced a visual document that was
largely dictated by the landscape itself. What a map might have
told her was worth photographing—a record-breaking bridge,
picturesque view, or historical site—was overridden by a less
hierarchical or culturally imposed system of significance. There
is a kind of apolitical purity to this approach, one that manages
to shake off the conscious and unconscious agendas that shape
our relationship to landscape. It is almost as if the river has one
truth, and this is it.

Which do you trust more, a map or a photograph?

In his series Mirrors, Dan Holdsworth presents amorphous, large-scale photographs of Washington State's Crater Glacier. Holdsworth cuts his photographs diagonally and then flips them to create two orientations of the same topography in a single image. This simple act of mirroring illustrates a common problem of apprehension that occurs when photographically mapping the world from above. Known as false topographic perception, this phenomenon makes it difficult to distinguish which features rise up from and which sink into the surface of the earth. For those who experience this sensation—commonly astronauts and pilots who do not, quite literally, have their feet on the ground—their understanding of landscape is in constant flux.

In some of Holdsworth's composites, a river might disclose the true contours of the topography (we know rivers run through valleys and not along ridges), whereas in others, no obvious clues can be picked out and we, too, are left unsure of what we are seeing. In an attempt to understand the landscape in this image, we must fall back on the conventions of visual language; art history and maps have conditioned us to prioritize information in the upper half of an image. But if this image were flipped, if the top became the bottom and vice versa, nothing would change, apart from our misplaced faith in vision; ridges would sink into valleys and canyons would rise up to become mountains. In his world of "mirrors," Holdsworth exposes a flaw in what we generally hold as our most valuable sensory tool. He shows us that when it comes to landscape, it is not always the case that seeing leads to believing.

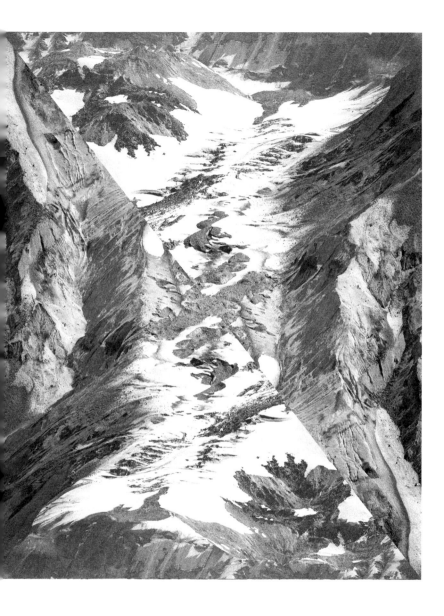

Mirrors FTP, CG, 19d, 2014

Above and following spread: Images from the series Conference of the Birds, 2020

Deciphering Sybren Vanoverberghe's photographs of a ruined Iranian village is a little like navigating stepping-stones. You jump to an image, linger for a few moments, then jump to the next. As you land on each "stone," you reassess your position, trying to remember your route while at the same time looking for your next leap. Gradually your path becomes less obvious. Is that leap too great? Perhaps the way forward means revisiting a previous stone.

Each of Vanoverberghe's photographs concentrates its composition around a single landscape feature, whether it's a crumbled wall or a leaning clump of palms. That same subject will appear in the next image, but from a different angle or relegated to a background detail. This allows us to create a mental map of the terrain. We begin to feel like we understand the village until the system breaks down. Occasionally, an image contains no such links to the previous one. This loss of orientation causes the village to crumble once more, only this time in our minds.

What do you mean when you say you "know" a place?

By tearing down his own systematic approach, Vanoverberghe exposes the tension that exists in the unseen territory between landscape *real* and landscape *represented*. In this case, he is specifically questioning the indexical nature of photography. In other words, we perceive photography, unlike drawing, as factual because its process relies on something being in front of the camera; yet here, without additional context, photography is defunct. It tells us nothing about the village, neither what it looks like nor what has taken place there. With his methodical approach, Vanoverberghe shows us that landscape resists representation. No matter how it is traversed, whether onsite or via some form of map, our understanding of a place is nothing more than a mental construct.

Walking was once a primordial act that connected us to the
land. Small, otherwise insignificant details served as marker
points, while faint, retraceable imprints left in the ground by
one's own body weight offered our signposts home. With his
series Day Drawings, Sohei
Nishino re-engages with
walking as a primordial act in
our era of digital traces. Using
GPS data, which has tracked
his walks through various
cities, Nishino re-creates his
routes on sheets of paper

Which is more tangible—
your shadow
or your
digital footprint?

with thousands of tiny pinpricks. Each hole becomes a footstep,
a physical representation of data. Once these perforations are
complete, and working in complete darkness, Nishino shines a
flashlight through the holes and captures the resulting path of
light with a long exposure.

Some of his routes amount to wiggly lines without appar-
ent logic; others depict the right angles, triangles, and squares
that denote city blocks, intersections, and sidewalks. In a paved
world of prescribed routes that are surveilled and turned into
data, Nishino's poetic representation of his walks, immortalized
by the ephemerality of light, becomes a meditation on human
existence: When walking through the city, is the path I cut mine,
or do I follow someone else's? What significance did I have in
that time and place? Do those journeys now exist only in my
mind, and the minds of passing strangers? Did I, in some way,
add to the layers of history, or did I vanish without a trace with
every corner turned?

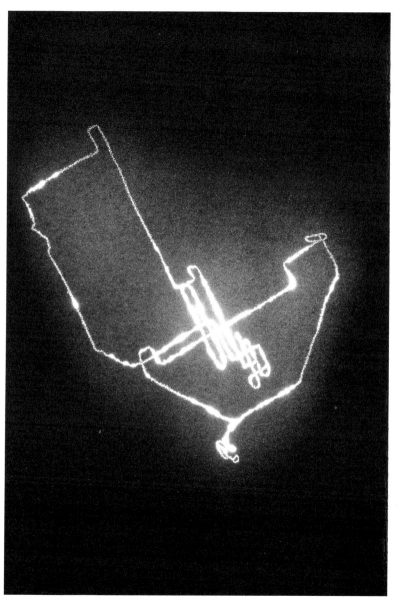

Above: *Day Drawing (San Francisco)*, 2016
Following spread: Images from the series Day Drawings, 2016

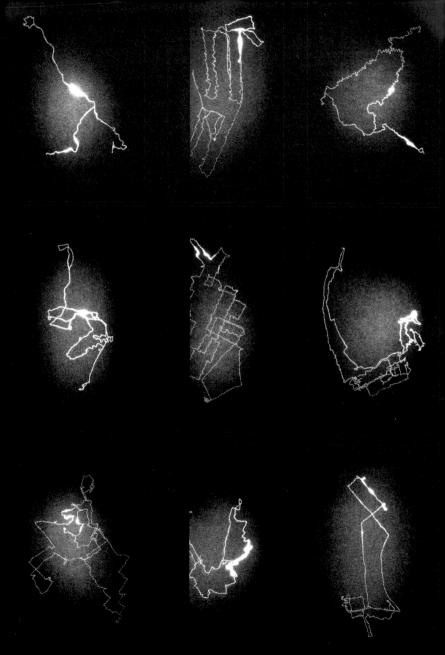

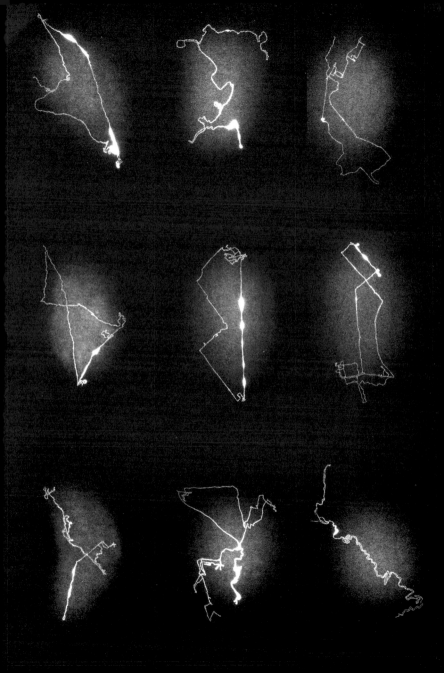

Above and following spread: *Postcard from Google Earth (48.408737°, -122.64598°)*, 2012

Reading those early lines of the Book of Genesis, I've always
wondered what the Earth would have looked like at the end
of each day. How could there be light on day one, but no sky?
And what was the texture of the land before God introduced
vegetation on day three? The Earth must have gone through
several stages of impossibility that only God could have created.
Clement Valla presents us with another impossible image of

Can a representation

replace the real?

Earth, this one
created by Google.
To make Google
Earth, a continuous
stream of photographs is taken, updated, stitched together,
and placed over a computer-generated model of the landscape,
like wallpapering a rock. But, of course, space and depth in
photographs is rendered flat, and here we see photography's
resistance at being forced to do something beyond its abilities,
even when aided by technology.

In his series Postcards from Google Earth, Valla traveled
around the world, albeit from his studio, taking screenshots
of wobbly roads and drooping bridges that were the product of
misaligned data, often corrected by engineers in a matter of
days. For Valla, these unexpected encounters offer a fascinating
vision or version of Earth that stands in total opposition to
Google's ultimate aim—to offer a view of the world that is
all-encompassing and unparalleled in clarity and detail. In
preserving these sci-fi-esque scenes, Valla presents a picture
of Earth, but it's not our Earth. Photography, in the traditional
sense, lies somewhere within these algorithmic anomalies,
but the medium has become lost within itself; it has become
unhooked from its role as "representer" and has made its
own legitimate world, an alternative planet. We can't be sure
which day of creation the Google God is on, but the process of
building a new world has begun.

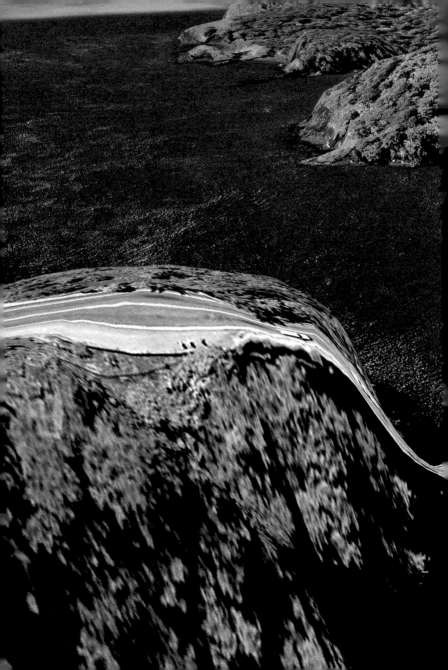

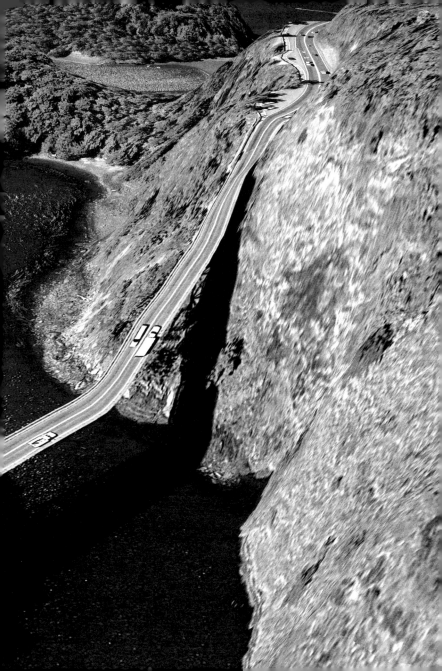

It was low season when I visited White Sands National Park in New Mexico, and I was one of only a handful of tourists seeking answers in the information center. "Drive all the way to the end of the road," said the woman behind the counter before I even asked her a question. "From there it's a five-mile hike into the dunes. Take water and be sure to follow the poles."

Thirty minutes later, I was alone under a clear blue sky, scaling up and down dunes that really did live up to their name. The aforementioned poles were six feet high and protruded from the sand every fifty yards. Often, they would fall out of sight when I was in a valley between dunes. As I continued walking, I found myself intentionally seeking out these moments of "polelessness," moments when I had no visible lifeline back to the car. Each time I ascended a dune and caught sight of a pole it was like coming up for air before diving down again.

Eventually, the dunes flattened out into an expanse of desert that stretched to low, gray mountains in the distance. I paused in the silent landscape. There was no wind. No aircraft overhead. Not even the default din of a distant highway. The only animal was me. Every crunch of every grain of sand underfoot, every breath in and out, I experienced in high definition.

When I looked one way, then the other, I heard the grinding of my neck joints. The intensity of the sunlight on the white sand gave me superhuman vision, bringing the tiniest details into sharp focus. Nothing interrupted my connection with the earth. The poles in the sand, my car, the woman in the information center, and everyone and everything else I know were part of some other plane of existence. Here and now, it was just me and the land and a whole host of clichéd descriptors that are unavoidable when trying to articulate this sort of thing. All I can say is that my undulating journey through the dunes must have been a form of hypnosis that allowed me to escape the human layer. A part of my inner mind had been unlocked, just for a few minutes, and I felt entirely fused with the vast expanse around me.

I imagine that the photographers in this section know this feeling all too well. Theirs is a relationship to land that is formed by something other than the politics of borders, mapping, and usage. They strive for a more primordial connection that responds to weather conditions, the psychology of light and darkness, deep time, solitude, geological forms, and even folktales. The images are often the result of a journey or a patent process whereby the photographers have allowed their surroundings to guide their visual responses. We see what is on the surface as well as what lurks inside—inside the Earth and inside the mind. The *innerspace*. Here, meaning is murky and through the eyes of photographers, nature and the built environment become defamiliarized and strange. What appears to be an alternate reality is, in fact, all around us. We just need to lose sight of the poles in the sand in order to see it.

SPACE

Sunlit branches encircle the composition like a gateway that slowly engulfs us, not entirely against our will, into a shadowy center. I, for one, do not feel threatened, even though I can only imagine what might exist in this darkness. Awioska Van der Molen travels alone, often sleeping in her car, and spends days in nature, purposefully disconnecting from the modern world.

Does landscape speak to you only when you are alone?

She works slowly, using a medium-format camera, and when she makes an exposure, it must feel like a momentary inhaling of light, a pausing of time between the opening and closing of the shutter.

More than simply a means of image-making, the act of photography becomes part of a process that sees Van der Molen enter ever deeper into a state of spiritual kinship with her surroundings. This shift away from "the outcome" releases her photographs from the responsibility of specificity or having clear meaning. And lacking locations, descriptive titles, and human figures, Van der Molen's photographs are not marred by national or territorial associations that so often override our primordial responses to nature. No political or environmental points are being made, no grand proclamations about surviving landscapes untouched by man. As such, our innate desires to know *where*, *when*, and *what* do not infiltrate our response. The relentlessness of the modern world falls away, and along with it the interference that now exists between humans and landscape. In Van der Molen's images, time has no real relevance; landscape becomes detached from culture, nonspecific, mentally malleable. It is a place of projection and reflection, a place that is fragile and sensuous. Perhaps for some these qualities are comforting, for others a little foreboding.

#274-5, 2011

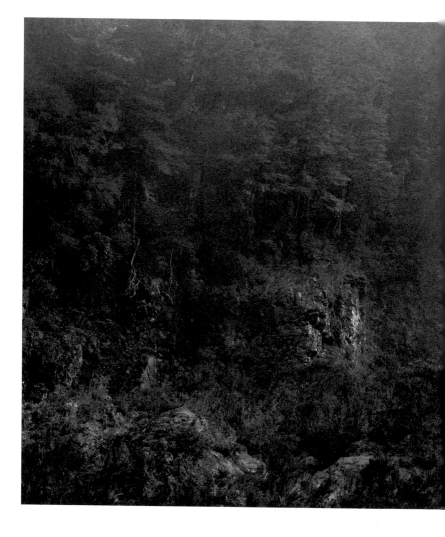

Left: *#448-18*, 2018
Above: *#206-8*, 2010

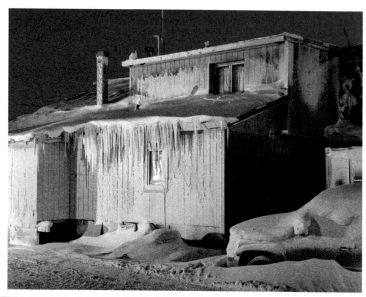

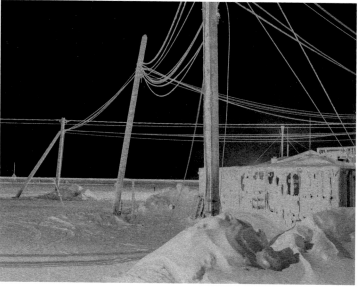

Images from the series Polar Night, 2019

No roads lead in or out. Not even Google has bothered to
Street View this town. Sitting 320 miles north of the Arctic
Circle, Utqiagvik is the northernmost town in the United States,
and for sixty-five days of the year, it is shrouded by night. Mark
Mahaney spent weeks documenting this isolated community for
his series Polar Night. He photographed snow-covered cars not
driven, icicles hanging over doors rarely opened, and telegraph
wires that look like rigging hanging from the leaning masts of
ghost ships. Though we do not see anyone on the streets, the
magenta shadows, sodium glows, and morbid tones of black
and white suffuse these images with the psychological hues
of the town's unseen residents. And when we view the images
now, following our own experiences of COVID-19 lockdown,
Mahaney's series manages to creep that little bit further into

**What reveals
itself in**

darkness?

our own acquaintance with pro-
longed isolation. For the residents
of Utqiagvik, sheltering inside, often
alone, often disoriented by the
enduring night, the darkness comes
with increased cases of depression,
substance abuse, and suicide. While

silence and stillness are expected from photography, these
qualities are somehow exacerbated in Mahaney's compositions
of community inertia. As in photographs of the lunar surface—
another unchanging, inhospitable landscape—it seems that here
time itself is frozen.

Does what we see
reflect who we are?

Delaney Allen's road trip through California was less about photographing what he encountered and more about photographing what he constructed. Allen placed colored gels over flash, illuminating Joshua trees, palms, and other spiky vegetation with hallucinogenic hues of pink, green, and cyan. And during the day, the ubiquitous nationwide retail outlets such as Walmart became foraging grounds for food, water, and other items with which to sculpt behind the closed doors of his motel room at night. His sculptures occasionally resemble specific landscape features that he photographed during his drive. At other times, they look more like time-filling experiments that test the limits of structural integrity.

Unlike photographers before him whose works came to define the photographic road trip, such as Walker Evans, Robert Frank, and Stephen Shore, Allen makes no attempt at social commentary; he is not driven to make a political comment about the American West. Allen's was a more expressive journey where landscape became a stage onto which he projected himself. The landscape is transformed into a world of mysterious apparitions and peculiar tabletop creations. It is an intriguing, unfamiliar response to such a well-explored genre and shows us that no matter where we go, no matter what we see and experience, the world "out there" is an extension, or a creation, of the world within.

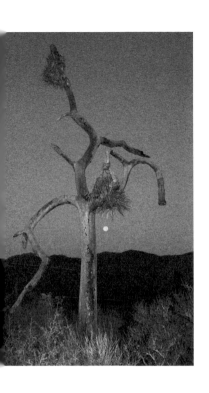

Images from the series Red Orange, 2016

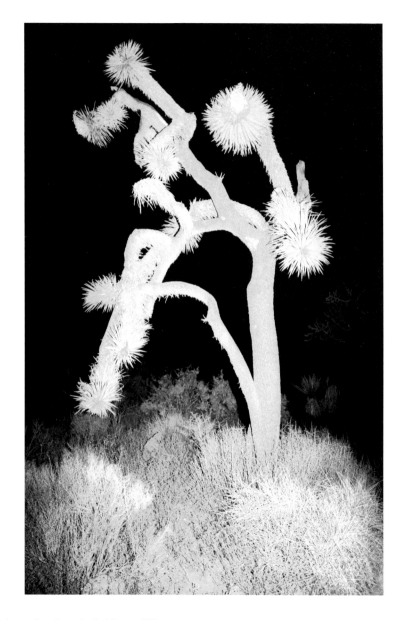

Images from the series Red Orange, 2016

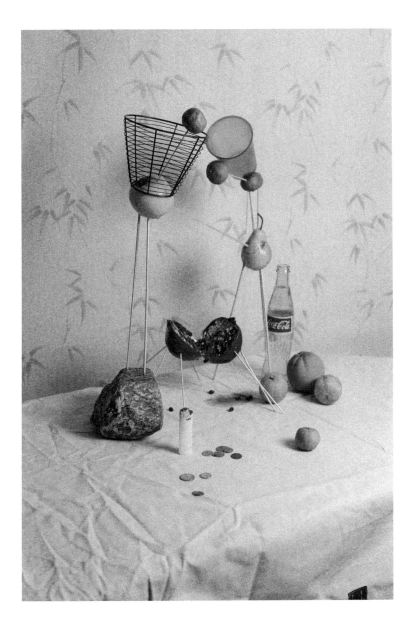

Above left: *Nyx #16,* 2018
Above right: *Nyx #8,* 2018
Following spread: *Nyx #60004,* 2021

Anna Cabrera and Ángel Albarrán take us back to an amorphous world before time. Theirs are images not to be looked at but to be immersed in. Starting with photographs of volcanic landscapes in Japan and the Canary Islands, Cabrera and Albarrán print in negative, flip compositions, and splice images together. The inclusion of gold leaf and textured papers, such as Japanese *gampi*, lends their works a precious and textural physicality. It is as if their handcrafted photographic process mirrors the constant layering and shifting state of land, and the materiality of the Earth becomes indefinable; what is fire, what ice, is hard to discern; swirling forms are either stone or ice; abrupt lines could mark the divide between land and sea or the converging of two rocks.

Are landscapes the memories of our planet?

Yet even in these primordial apparitions, hints of humanity, civilization, and culture can still be felt, if not seen. In some compositions, Cabrera and Albarrán reference the visual language of *haboku*, a Japanese painting technique of sparing gestural brushstrokes that appear nonrepresentational. Soon, however, a landscape emerges from the marks, almost as if the painting itself is shifting before our eyes. References to the Greek creation myth also rise to the surface. The ambiguity of what is earth and what sky, the glinting of gold leaf, and the apparent formless chaos recall the formation of Gaia (Mother Earth), Uranus (the sky), and Nyx (the goddess of night). These cultural interpretations that we impose onto Cabrera and Albarrán's primordial landscapes fuses us with what initially appears unrecognizable and otherworldly. Land becomes a complex, messy, and layered accumulation of geological restlessness, imagination, and shared memory. We are the land, and the land is us.

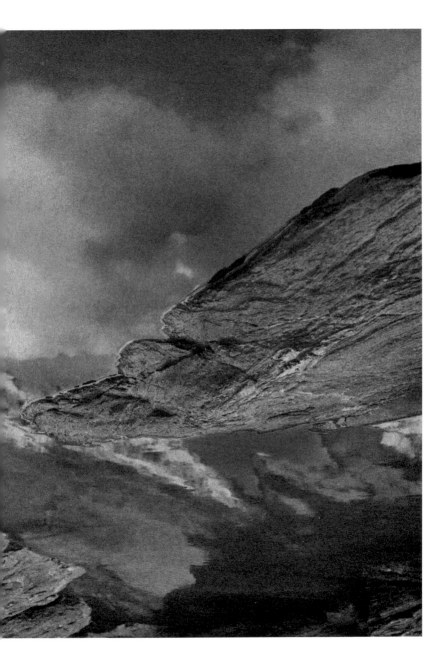

Which frees
your
imagination
more,
gardens
or the
wilderness?

Just like the formal gardens that serve as her subject, Beth Dow's compositions offer us glimpses into light-filled openings and narrowing paths leading around shaded corners. Dow photographed gardens in England and Italy, fascinated by the millennia-old traditions of sculpting nature into safe, meditative environments that allow us to be with our own thoughts without the distractions of aesthetic imperfection or threats of wilderness. Yet formal gardens are not without mystery. The placement of trees and hedges reveals and conceals; physical pathways become neural pathways, leading us to decisions as well as destinations.

The allure of a formal garden, then, is not unlike that of a photograph; one cannot be sure what lies around unseen corners, and one can never be sure what lies outside the photograph's frame. And in making her impeccably crafted, tonally sumptuous platinum prints, Dow draws another parallel between the photographic process and the creation of these

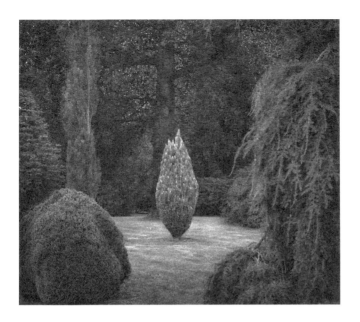

gardens: Both are the result of a patient fine-tuning designed to guide us around a space in a very precise fashion; the gardener plants bushes, prunes trees, and cuts grass to the perfect length, whereas Dow uses cropping and dodging and burning to lead our eye through her images.

All gardens, no matter how vast or intricate, eventually reveal themselves. Their pathways soon become navigable; their mysteries anticipated. However, the gardens in Dow's photographs remain unfamiliar and impossible to navigate. Several gardens form one immersive landscape that absorbs us ever inward. We find ourselves enveloped, cushioned in a state of perpetual beauty and contemplation. Each point of interest is isolated from the process of discovery, from a linear journey through space and time. The gardens become a little less predictable, a pristinely manicured wilderness, a landscaped landscape that, unlike a real garden, does not offer us a way out.

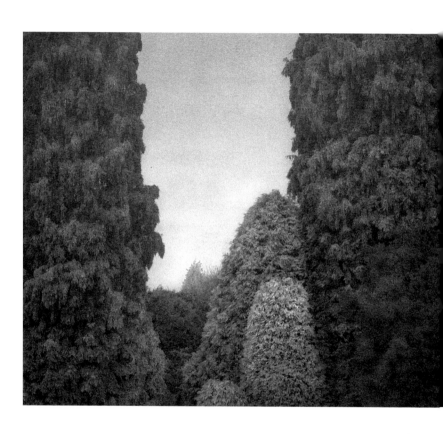

Above: *Pinetum*, 2004
Opposite: *Passage*, 2003

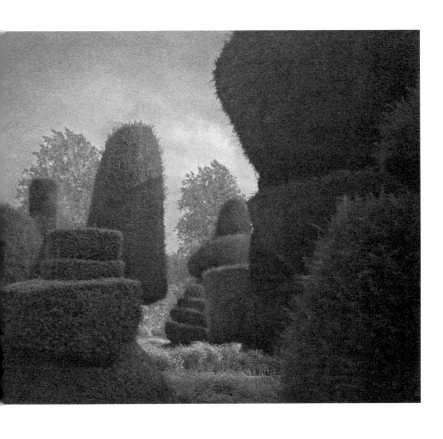

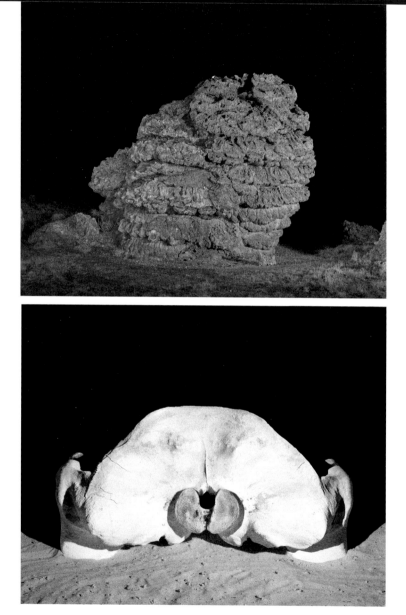

Top: *Moonrise*, 2018
Bottom: *Remains Found in Drifting Sand*, 2017

In Michael Lundgren's starkly lit photographs of amorphous rocks and other landscape features, it's difficult to tell what might have been carved by hand or by nature. Even the reassuringly familiar materials of wood and stone are occasionally hard to distinguish from each other. And where

What does "deep time" look like?

exactly does Lundgren find these strange forms? Perhaps they protrude from the craggy slopes of mountains, grow from the sands of remote deserts, or lurk inside dark caves that once offered haven to early humans. Those questions, I suppose, are precisely the point. Because this is clearly not a look at landscape intended to elicit rational explanations about the existence of things.

Lundgren's photography serves to obfuscate as well as clarify. He wants to entice us away from the familiar and welcome us into an unfathomable world shaped by human hands and deep time, into a place where mysticism, science, and civilization coalesce. Direct lighting from varying angles casts shadows in multiple directions, and forms are isolated against blackness. What is depicted here—the ruins of a sculpted pelvis, Greek or Roman, perhaps, or some kind of dried sea coral? In all this ambiguity, a fascinating notion rises to the surface. Lundgren is suggesting that our recent emotional and physical distancing from geologic and human history allows us, if we wish, to view the natural world as something entirely alien. Paradoxically, in this state of wonderment and unease, we form a new appreciation of, or bond with, an ancient world to which we owe everything.

If rocks could
talk,
what would
they say?

The mystical powers and alchemic properties of precious stones mined from the earth form the basis of Johan Rosenmunthe's elusive investigation titled *Tectonic*. His image of a smartphone leaning against dazzlingly speckled rocks reminds us playfully that the technological marvels of connectivity are very much reliant on rare-earth offerings such as cobalt, copper, and gold. Elsewhere, Rosenmunthe plays with the language of scientific imagery and product photography to present tongue-in-cheek still lifes that speak to the various states of rocks and crystals.

Multicolored specimens sit on "do not touch" pedestals like a council of wise crystals, a bunch of rose-quartz grapes hangs over wood-laminate flooring, a stone rests on a red cushion as if it's a sacred offering, a glowing decanter stopper looks like it's floating in outer space, and is that cube of strata on silk a stack of sticky notes? Searching for meaning in Rosenmunthe's work is a little like searching for meaning in the earthly matter he depicts. We don't seem to be content with something simply *being*. Surely art has to mean something, surely there is cosmic power and energy contained in ancient rocks. But that's just it. *Tectonic* is a crystal sitting in the palm of your hand. You can play with it, stare into it, and squeeze it all you like, but the answers you hope to find will never be revealed. At least, not in the definitive way you may wish them to be. It is this enigmatic, purposefully ungraspable quality that makes Rosenmunthe's work so alluring. Your search for meaning is the meaning.

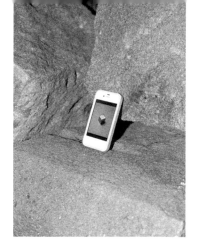

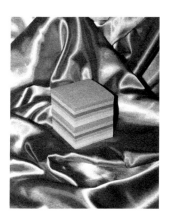

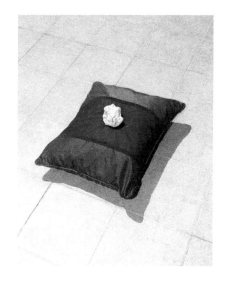

Clockwise from top:
Social Context, 2014; *Atom*, 2014; *Layer Study*, 2014

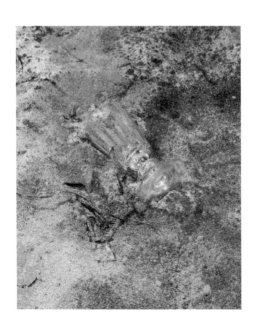

Clockwise from top right:
Korund 1, 2014; *Magnesia*, 2014; *Rose Quartz Resource*, 2014; *Vision from the Beach*, 2014;
Object, Reflection, Dust, 2014

The dovecote no longer serves a purpose, other than as a reminder. For centuries, it was a place to keep pigeons, but the birds must have fled when the roof caved in. Its four walls still stand tall on the brow of the hill and continue to cast an ominous presence over the landscape, always there, their edges sharpening and softening in the changing light.

CON STRUCT

I hate that tower—I've hated it ever since I was sent to boarding school in the town at the bottom of the hill. Its hollowness, its isolation, its dereliction became highly visible symbols of my debilitating homesickness. The tower was inescapable, just an unresponsive observer, a barren beacon that insisted on being visible from the musty dormitories, stale classrooms, and frozen playing fields. Even today, I would love nothing more than to see its walls crumble, to see the brow of the hill returned to a nondescript curve of green against blue. I'm sure the dovecote means something very different to the other students. Perhaps the sight of it, the memory of it, provides them with great comfort, a warm reminder of their once-carefree existence in the English countryside. No doubt they have set up an alumni fund in order to restore the dovecote, to preserve it as a rose-tinted monument to the happiest days of their lives.

The British landscape photographer Fay Godwin once took a photo of the tower. She came and went long before I knew of its existence. In her image, the tower appears gaunt and hollow against a winter sky, and a playing field, probably frozen hard, lies in the foreground. The tower must have meant something different to Godwin, yet her image managed to capture a perfect premonition of my homesickness, my state of abandonment. Like Godwin, the photographers in this section draw our attention to very specific forms in the landscape. They reflect on the influence such forms—whether human-made or natural—exert on their surroundings, suggesting that our responses to landscape are subjective and personal and meaning is never fixed. Just as I did in my response to the dovecote, we bring our own psyches, our own foibles and fears and hopes, to whatever landscape we inhabit. We latch onto specific features for specific reasons. There is not just one dovecote, but thousands, each version existing in the mind of someone who has seen it. When I looked up at the hill, I did not see the dovecote, I saw "my" dovecote. I built the tower. I constructed the very thing I so despise.

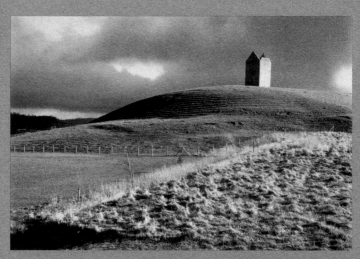

Bruton Dovecote, Somerset, 1983

Does a rock exist

outside of time?

It is a striking rock, no doubt about it. In some of Thomas Lohr's images, it appears to cut through the sea like a shark's fin, or list gracefully like a sailboat. It is sometimes jagged like a knife, or defiant like the rusting debris from a wrecked ship. If it were a commissioned sculpture, its form might feel a bit trite, a bit too obviously inspired by its surroundings; as the product of nature, the rock is not subject to the same critical scrutiny and is, by default, perfect and timeless. No wonder Lohr traveled each month from London to the southwest of England in order to visit the rock. In total, he spent two hundred hours in its company, photographing it at various tides and in various seasons.

In his resulting series titled Gezeiten (the German word, meaning "tide," incorporates the word *Zeit*, meaning "time"), no two captured moments are the same. The light, the sea level, and the accumulation of sand are in a constant state of flux, yet the rock itself, always pictured from the same side, remains unchanged. Whether half submerged or half buried, reflective like graphite or greenish with lithophytes, its form is mesmerizingly, almost inconceivably, constant. For Lohr, the rock took on the role of a long-distance lover who was always there waiting for him to return, a reassuring anchor of stability in an unpredictable world.

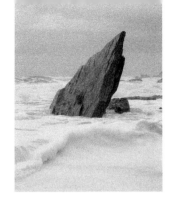

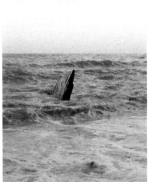

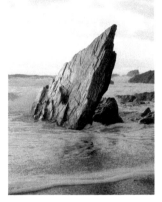

When we look at Lohr's series, time collapses into something less linear. The flow of images might read as a narrative, but the subject does not change; it seems to exist outside of time, an illusion heightened by the ever-changing state of everything around it. In contrast to the water, light, and skies, the rock feels as frozen in time as a photograph, its permanence challenging the medium's claims of immortalizing its subjects. Our own sense of existence also plays its part. The attrition of the sea may take its toll on this rock over millennia, but the opening and closing of a camera's shutter, or the passing of a month, a year, or even the span of a human lifetime is, to the rock, utterly inconsequential.

Above and following spread: Images from the series Gezeiten, 2016–18

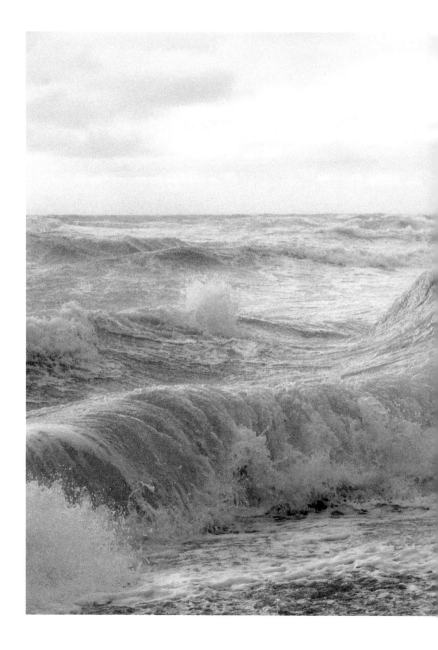

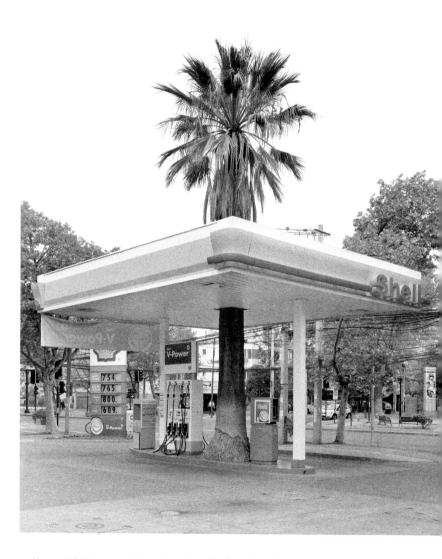

Above and following spread: Images from the series Quasi Oasis, 2012–13

Lone trees, specifically palm trees, attract the eye of Sebastian Mejia, who navigated Santiago, Chile, guided by glimpses of these natural spires. In his stylistically straight photographs, the trees appear a little inconvenient compared to the functionality of the apartment complexes, parking lots, and car showrooms from which they protrude. In some cases, their presence is so

Can nature and the built environment truly coexist?

inexplicable that they look almost Photoshopped in place. The contrast between natural and artificial forms is nowhere more evident than in this image. A gas station, the antithesis of nature, has a stranglehold on the tree, cutting it in two and making it appear to be an integral part of the structure, its fronds spreading out like a star.

One could read this as an attempt to preserve nature in the urban environment, yet there is something begrudging, something less than respectful, in the way the architecture incorporates the tree. If anything, this arrangement highlights the fragility or redundancy of nature, its vulnerability to the whims of progress. The trees in Mejia's photographs take on a certain quaintness; they are oddities to be preserved until they become too bothersome, or until the rising value of land precludes the preservation of something as unprofitable as a palm. A state of tense coexistence can be felt, one in which the trees struggle to maintain their natural integrity. Competing for space amid the concrete, the palms start to seem as artificial as the human-made forms that surround them.

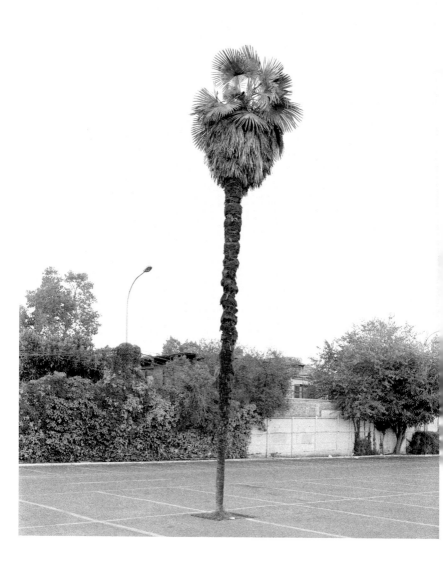

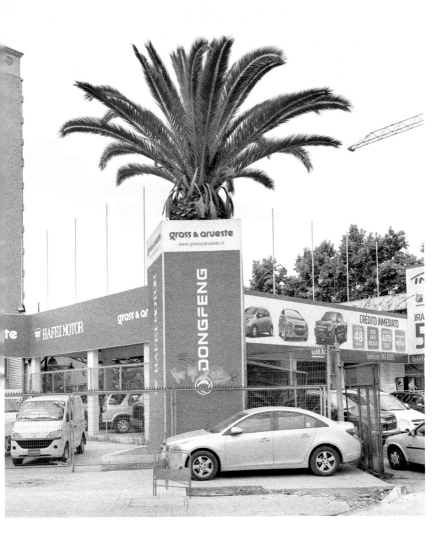

Is time perceptible?

Even though each of Nicolai Howalt's ninety-seven photographs of Old Tjikko, a 9,550-year-old Norway spruce, looks different from the others, they are all hand-printed from a single negative. Thanks to Howalt's use of various types of photographic papers, some long expired, the tree is represented through a mist of printing imperfections and varying degrees of contrast. In some, Old Tjikko is barely visible in what looks like a snowstorm; in others, the tree appears silhouetted against a night sky. But in fact, nothing has changed. No seasons have passed. It is the same tree, preserved for some unfathomable reason by nature and immortalized here by photography.

In contrast to digital images, which are essentially infinitely reproducible sets of code, the combination of film and fine art papers manages to present a more fragile and enduring connection between photography and nature. One that is more respectful. The actual prints themselves seem in some way to contain a trace of the tree's silent majesty. Through the act of making multiple prints from the same negative, Howalt uses photography—a medium that's often seen as instantaneously neutralizing the sublime—as a means of comprehending and connecting with one of the oldest living trees on earth.

Opposite: Images from the series Old Tjikko, 2019

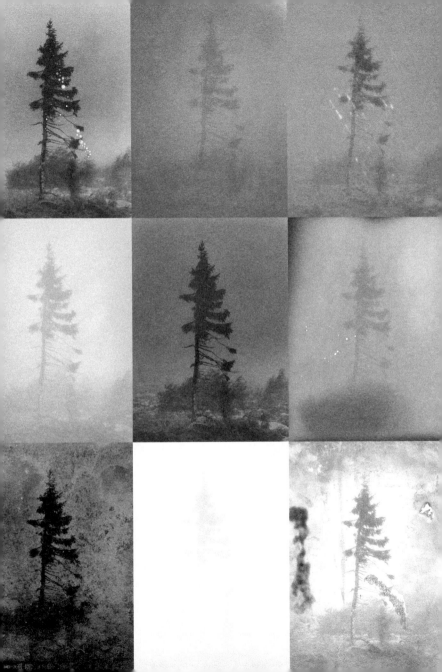

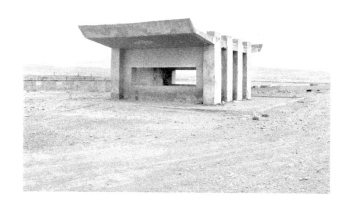

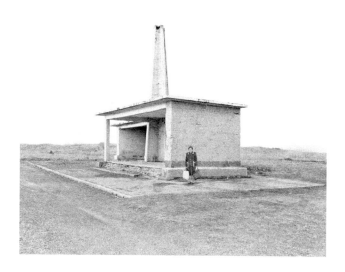

Top: *Erevan-Gymri/USD*, 2000
Bottom *Sevan-Erevan/USD*, 2011

What is a monument?

It is a bus stop. That is all. Photographed by Ursula Schulz-Dornburg, imposing examples of infrastructure like this were built in the 1970s and `80s by the Soviet-era socialist government of Armenia, intended to stand as symbols of promise and progress, portals that could connect people to jobs in nearby towns and cities. Unfortunately, that bright and prosperous future never arrived. Now these concrete structures in an otherwise barren landscape appear like monuments to the collapse of a once-mighty system of power. In some of Schulz-Dornburg's images, the bus stops look like abandoned shells, their slow state of decay making them reminiscent of other, far older ruins of fallen empires that also punctuate the landscape in this part of the world. In others, figures can be seen waiting patiently, presumably for a bus that may or may not appear on the horizon—a reminder that the politics of the past still influence the present.

By turning her attention to something as seemingly banal as bus stops in an ancient landscape with so much architectural evidence of civilizations come and gone, Schulz-Dornburg presents us with a graspable connection to the turnover of history. No empire, no system of power, is permanent, yet the remnants of such an empire's architecture still lay claim to the landscape. As long as they stand, these bus stops will cast an ominous shadow. The regime may have fallen, but people continue to stand under its crumbling canopies.

LETHA
WILSON

What is lost when a landscape is reduced to two dimensions?

What is it about photographs that commands so much respect?
Ideal photographs are pristine, without dust or scratches; they
hang on walls in frames and cannot be touched without white
gloves. They are two-dimensional, their surfaces flawlessly
even. They are, in short, the opposite of reality, especially
the realities of landscape. In Letha Wilson's works, however,
photography becomes sculpture. Photographs of the canyons
and deserts of the American West are overlaid with the building
materials of humankind: concrete, timber, steel, and glass.

Here, a photograph of a giant ponderosa pine, with its
shadow falling on an enormous rock, is printed at large scale
and exhibited at an angle. The white, wooden supporting
column of the gallery pierces the image, obscuring the tree.
This causes the three-dimensional space of the gallery and the
flat space of the photograph to become confused, the shadow
of the tree now looking like it is cast by the architecture. In
Wilson's work we see photography's limitations exposed, and
yet she also elevates the medium into something perhaps
even more representative of the natural and human-made
forms found in landscape. Wilson, who grew up in the epic
landscapes of the West, offers an emotional, rough-and-ready,
get-your-hands-dirty kind of connection with nature, one that
photography, with its pristine finish, tries its utmost to deny us.

Opposite: *Ghost of a Tree*, 2011

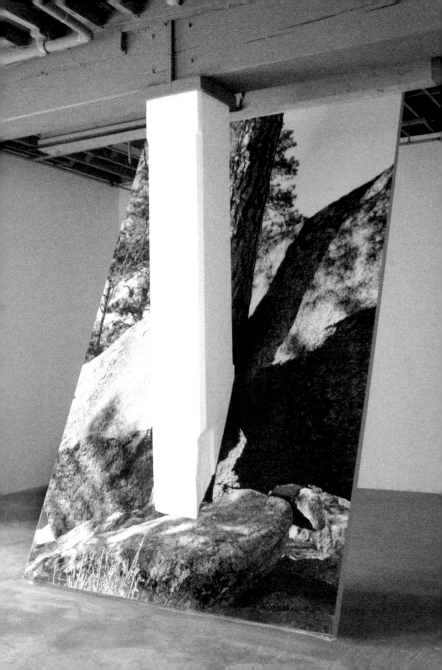

Above: *Street View*, 2013
Following spread: *Playground 2*, 2010

There's an online game called GeoGuessr. The game puts you in a randomly selected location, anywhere in the world, using Google Street View. You then have to analyze your surroundings to figure out where you are. If you were dropped into one of Lauren Marsolier's images, however, this process of deduction would be impossible. Using Photoshop, Marsolier

How do you know where you are?

stitches together elements from multiple photographs of various locations to create new, imaginary spaces that feel familiar, but leave us a little adrift. Street signs are stripped of words and symbols; roads surfaces and building facades are unnervingly clean compared to the natural rock formations; pastel architecture is either blankly stark or decorated with Romanesque flourishes, the kind that appear all over the world.

Light is another disorienting device in Marsolier's images. The blue skies are usually cloudless, yet either the harsh shadows one expects from the bright midday sun are soft or their sharp lines fall at slightly different angles. In this image it is clearly daytime, yet the illuminated lamppost casts a surreal, Magritte-like quality over the scene. The strangest, most unnerving aspect of Marsolier's work, however, is its familiarity. Our globalized world means that architecture and landscaped spaces are becoming ever more uniform. Lush green grows in desert cities such as Dubai and Phoenix; logos of multinational companies are ubiquitous; even the interiors of apartments and offices are everywhere decorated with the same flat-packed furniture. As a result, our awareness of geographic specificity and of our mental and physical place in the world is becoming ever more vague. Marsolier's images may deposit us in a constructed world between real and fake, here and there, past and future—but isn't that the limbo we already occupy?

It's September in Southern California, and the wildfires have already started. I can't smell the smoke as I run along the beach, but the midday sun, diffuse and perfectly round in a sepia sky, tells me it is there. I stop to catch my breath. At my feet, the top of a bottle protrudes from the sand like the tip of a plastic iceberg. I contemplate picking it up. Nearby, a lean, leathery man in his fifties is leading a yoga class. "Now come up on your arms and lift your heads to the sky," he says to his four students. "See the plane above. Breathe in and follow the plane as it glides across the sky . . . Exhale, and down." It was quite something, observing how the instructor so effortlessly incorporated an airplane, one of the world's worst carbon emitters, into an upward-facing dog, and even more jarring that the plane's contrail provided his students with a sense of well-being. I felt like stepping into this little bubble of serenity, as if by doing so I could make the burning forests, the day turning to night, the polluted sand into figments of my imagination. I looked out to the bronze, unusually placid ocean, transfixed by the foreboding beauty of it all. What is this strange new world we have created for ourselves, I wondered, and why does it feel so normal? Then I continued my run, leaving the plastic bottle in the sand.

It is these all-too-familiar dualities—our ability to see the beauty in devastation, to ignore the consequences of our actions, to emotionally disconnect from what is happening around us, to judge the actions of others while being oblivious to the insidiousness of our own—that the photographers here explore. Though they respond to climate change and other violence inflicted by humanity on the earth, their work avoids picturing scenes of catastrophe—the sorts of scenes that serve as the strangely alluring call-to-inaction photo-fodder of Instagram. Instead, they open the door to a more contemplative visual space, one that allows us to question the psychology behind our actions. Often their work finds beauty in environmental destruction, because in beauty there is hope. And as they direct our attention outward, a fundamental truth is revealed, perhaps the most insurmountable truth of all: If we are to overcome environmental catastrophe, we must first overcome ourselves.

Life goes on in a city slowly succumbing to the rising sea. Amid the ever-increasing wrath of hurricanes, luxury apartments continue to be built, lawns are watered, swimming pools are cleaned, and tourists sunbathe on the sand. It is this state of inaction, of resignation and acceptance, that Anastasia Samoylova captures in her photographs of Miami. Without depicting catastrophe itself, Samoylova makes us feel its looming presence in the quotidian corners of Floridian streets.

Her photographs occasionally verge on the abstract, with layers of "reality" compressed into single images. Aspirational advertisements presenting idyllic visions of new apartment complexes are sandwiched between a foreground and a background of construction detritus. No matter how urban the

Is the future real or imaginary?

scene, nature is always creeping and seeping into Samoylova's images. Subtropical vegetation reclaims concrete structures; stagnant seawater turns streets into canals. This contrast between civilization and nature speaks to our internal conflicts about confronting climate change, conflicts that often result in a kind of pathological inertia, even when the dire outcomes of our excesses are finally upon us. For so long, the future did not exist. It was an imaginary place where all problems will be solved by the actions of others. With her series FloodZone, Samoylova shows us that the future is now and that, nevertheless, we cannot accept its reality.

The humidity is high in these photographs, and the water is looking jittery. Raise the sidewalks, board up the windows, and cover the car. What else are we supposed to do?

Construction in South Beach I, 2017

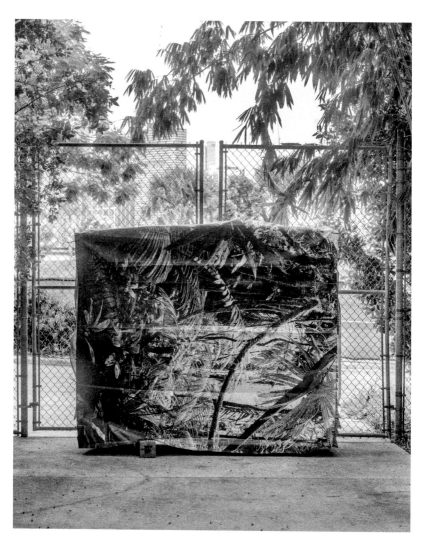

Above: *Camouflage*, 2017
Opposite: *Pink Sidewalk*, 2017

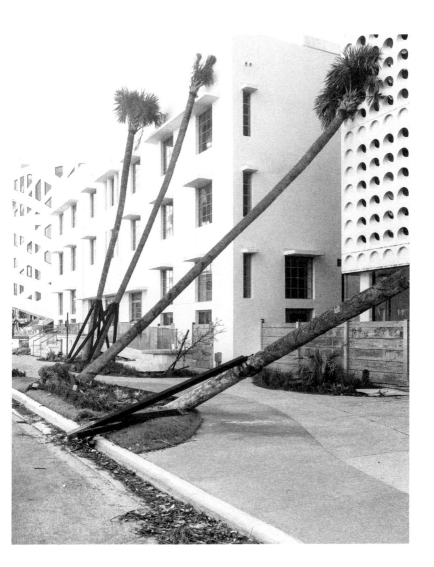

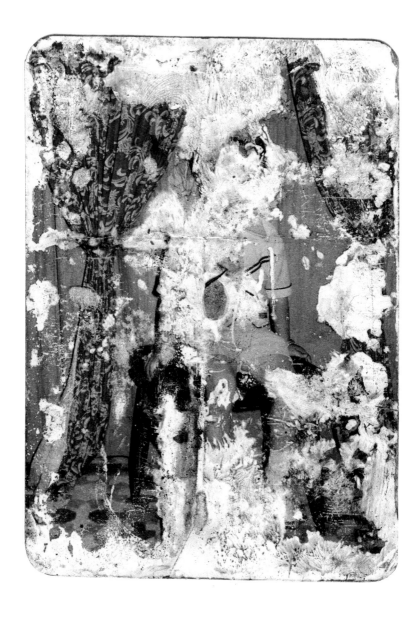

From the home of Comrade Abdul Rashid Bemina, Srinagar, Kashmir, India, 2014

The subjects in the photographs rescued from floodwaters
by Gideon Mendel are obscured by peeling emulsion and the
chemicals contained within the prints. Precious keepsakes
depicting sons and daughters, birthdays, weddings, and summer
holidays have been ravaged by nature; only small traces of
people and places are preserved. Some of the photographs are
imbued with a profound sense of loss, others are bittersweet—
the azure waters of a swimming pool are enticing, clean, and
perfectly contained, unlike the flood from which the photo was
saved. The once-innocent subject matter of other photos takes
on new meanings.

A commonplace shot
of an airplane's wing
taken through the
window serves as a
reminder that our
thirst for cheap air

**What becomes of memories
if no one is around
to remember them?**

travel and excessive fuel consumption are partly to blame for
the rising waters. Damaged beyond recognition, these memo-
ries become generalized, abstracted. The photographs might
once have belonged to those living on the frontlines of climate
change, but they contain the collective memories of us all: our
loves, our joys, our indulgences and excesses. Photographs
preserve life, make permanent the transient, yet here their
materiality and the memories they contain are revealed to be
anything but lasting. In these fading prints, Mendel finds a way
to represent the human condition, our illusions of permanence,
our fragility in the face of climate change.

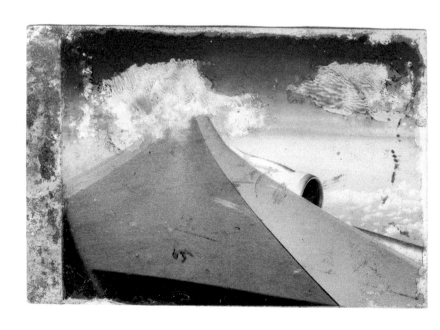

Above and opposite: *Found on Goburra Street in Rocklea, Brisbane, Australia,* 2011

Is destruction a necessary part of creation?

"The man who moves a mountain," mused the Chinese philosopher Confucius, "begins by carrying away small stones." Two thousand years ago, modest amounts of white marble were indeed taken from the mountainsides of Carrara in northern Italy. The marble was used to make sculptural masterpieces and to cover the floors of mosques and churches. Today, however, monumental chunks are extracted with industrial machinery to satisfy the global desire for this valuable rock. In her series Carrara, Aglaia Konrad presents a landscape exploited into brutalist angles, unnatural edges. What took billions of years to form is now being rapidly reshaped by brute force.

From this raised vantage point, graceful ridges of dark, mountainous peaks descend into zigzag roads and colossal terraces of white. Those quarrying the rock may not be concerned with aesthetics, but the landscape takes on an architectural or industrialized beauty: organized, manufactured, and abstract. It is an awe-inspiring spectacle, not far removed from the Inca citadel of Machu Picchu, only at this site there is no evidence of respectful coexistence between humans and nature. In other images, Konrad takes us to ground level and occasionally inside the excavated chambers of the mountain.

Drawing on the industrial reshaping of the mountain, she adopts a similar process of deconstruction and construction. Black-and-white images that have been joined together serve to further abstract the landscape; the sharp lines of the rectangular frame momentarily appear as if they are carved into the rock. Just like the landscape itself, new compositional formations, stark and aggressive, arise from the conjoined images. A peculiar, even perverse tension starts to emerge in Konrad's work—this mountain has not been moved; it has been almost entirely eviscerated. Even so, there is undeniable beauty in that destruction.

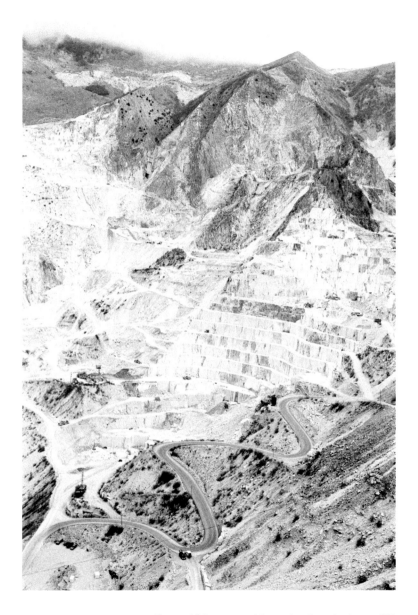

Above and following spread: Images from the series Carrara, 2011

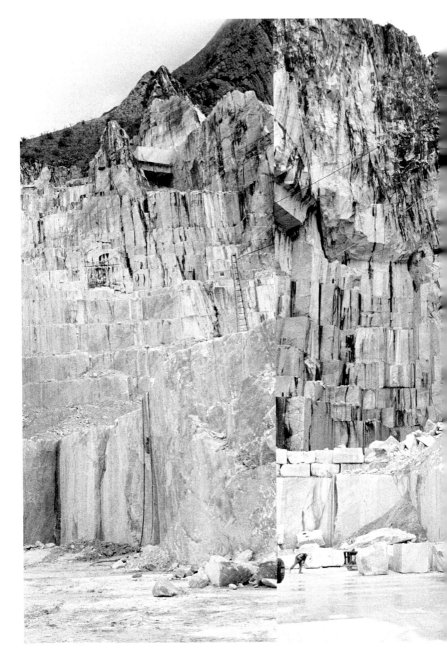

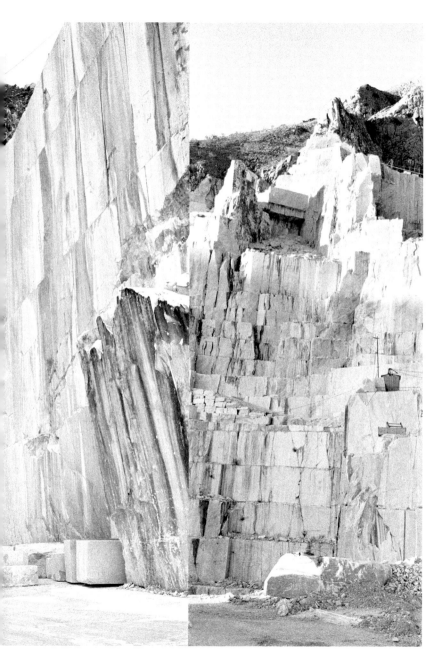

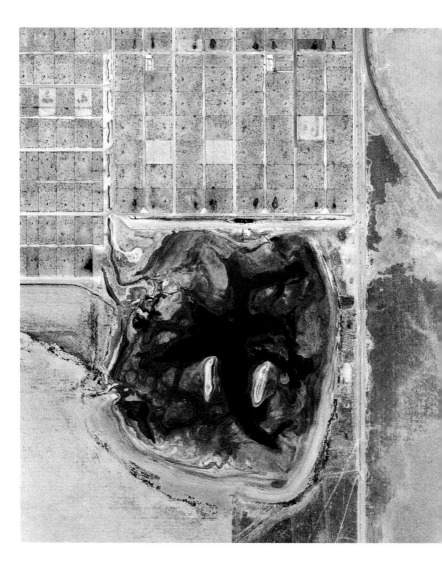

Coronado Feeders, Dalhart, TX, 2012

Though we cannot immediately tell what we are looking at, there is a clear sense that

Does the earth feel pain?

it's far from benign. Mishka Henner discovered this disturbing entity in the land on Google Earth. It is a feedlot, a place where cows are packed into pens and pumped with hormones and antibiotics before being slaughtered for their meat. In order to comprehend the sheer scale of such factory farms, Henner proceeded to stitch together screenshots to achieve high-resolution images of feedlots across America. This particular example, in Texas, is dominated by a contaminated lagoon of waste, its violent color the result of a specific concoction of chemicals used to treat the by-products of cattle processed at the farm.

The aerial view, an abstracting visual device that usually suggests objectivity and emotional distancing, instead provokes an almost squeamish reaction. Against the dry, brown earth, the vivid shades of red appear like muscle, blood, and other living tissue. The land is repulsive; the view is like peering into a dissected and diseased vital organ that has been exposed to the air. The details of the farm itself, such as the cows, appear as insignificant as ants, and although we cannot see any humans they must be there, invisible yet ever-present like bacteria. Picturing land from a vantage point where we are undistracted by ourselves, Henner reminds us that the earth is not only something we live on but a living organism itself, a body like any other that is susceptible to injury, that can be wounded and abused, even by a life-form of its own making—us.

Is there anything that cannot be sacrificed?

The concrete remains of a bridge look like the ancient ruins of a fallen civilization. Through the haze, skyscrapers stand tall on the opposite bank. Between these two visions of past and future lies an almighty river, lifeless and gray, like a piece of collateral damage in the name of progress. The people in the foreground, however, seem to be using this destitute spot as a landscape of leisure. Their insistence adds a touch of humor to Zhang Kechun's composition, although perhaps there is a little too much truth in the joke for it to be actually funny.

Kechun has dedicated his career to photographing the postindustrial fallout of China's unstoppable growth—specifically its impact on the Yellow River. This natural wonder, imbued with spiritual significance and regarded as the cradle of Chinese civilization, appears exploited and abused in the photographs. All those myths, all those legends, have been washed away like silt, leaving this river as a drainage system for the densely populated urban centers that line its banks. Kechun's use of stagnant yellowish hues and flat, overcast skies makes the images themselves feel almost polluted, and his layering of dereliction and development encapsulates the insatiable drive of a country determined to keep moving forward at any cost.

But as we can see by the presence of people, the river still has a draw; it still means something to some. It is this human element that provides us with a little hope, a way to contemplate our connection to the land. Here time has been paused. With the waters stilled and the construction sites silenced, we are afforded time to think, a moment to question whether the future is not, in fact, on the other side of the river, but right there, in the foreground.

From the series Tea Drinkers by the River, 2014

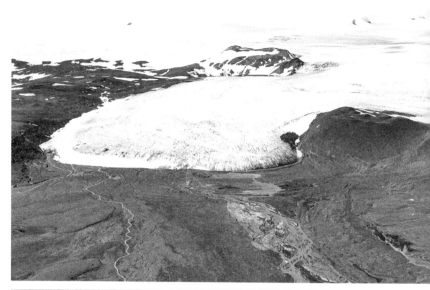

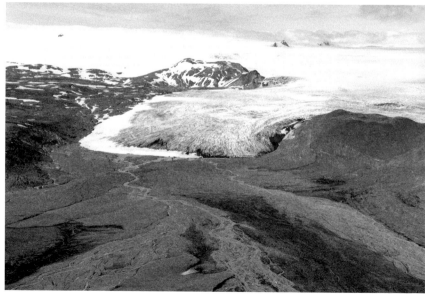

Above and following spread: Images from the series The glacier melt series, 1999/2019, 2019

At first they look like two different landscapes, until certain similarities in the contours of the rocky terrain start to emerge. They are the same landscape, the same glacier. This realization confronts us with a question: What is the time difference between the first and the second image? In 1999 Olafur Eliasson photographed dozens of glaciers as part of an ongoing project

Is this the end or simply a new beginning?

to document the sublime, primordial majesty of Iceland. His stand-alone images formed a collection simply titled The glacier series. In 2019 Eliasson returned to the same locations. The result is a set of thirty paired images presented in a grid with the new and more ominous title, The glacier melt series.

There is no escaping the distressing reality of what we are seeing: the rapid, irreversible shrinking of colossal and ancient natural forms. But there is also something about these views that is not entirely hopeless. The glaciers' shift in appearance, from healthy and swelling to weak and diminished, stirs a very human response: empathy. It is almost as if these hunks of ice

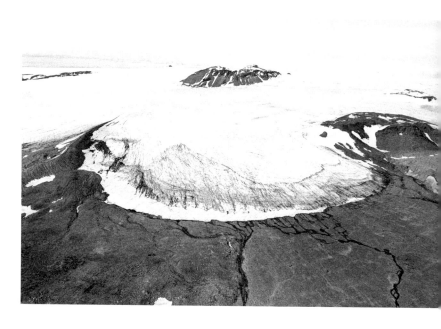

are living creatures experiencing pain, injured beasts retreating in order to heal. Though it will take an ice age for the glaciers to return, the sight of them suffering offers a rare and monu-mental pause for thought. Perhaps, just perhaps, we humans need to experience loss in order to realize the preciousness of everything that remains. What is done is done, but do we now allow nature time to recoup its strength, or do we keep going, do we continue to inflict one deadly blow after another?

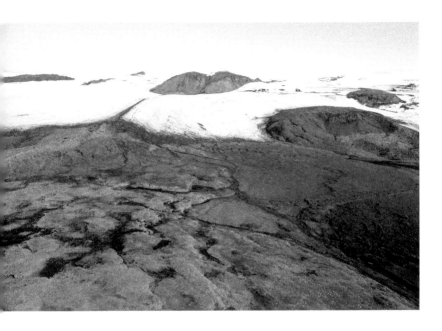

When a photographer returns to the same subject after time has passed, the resulting two images often feel like a before and after, a definitive beginning and end to the narrative. Eliasson's image pairs do not feel like that. Neither image serves as a beginning or an endpoint. I can imagine Eliasson returning to the glaciers in another twenty years and a new series will emerge, the title of which will not be only up to him. That is something we all get to decide.

PHOTO CREDITS

ACKNOWLEDGMENTS

I would like to extend a gargantuan thank-you to the following people whose experience, creativity, and insight helped to shape this book. To my editor, Michael Sand, and the design and editorial team at Abrams: Diane Shaw, Deb Wood, Elizabeth Broussard, and Glenn Ramirez. Thank you to my kind and supremely talented personal editor, Riley Johnson, for his ongoing and thoughtful comments, and to my agent and voice of reason, Katherine Cowles. Image research was undertaken by the unstoppable Kim Hungerford and Jack Harries of RAFT, and further thanks go to James Bryant, Selwyn Leamy, Caitlin Walsh, Dan Golden, and Lukasz Pruchnik. And, of course, thank you to all the photographers who generously contributed work and so graciously tolerated my working methods that were, at times, a touch chaotic.

Editor: Michael Sand
Managing Editor: Glenn Ramirez
Designer: Diane Shaw
Design Manager: Shawn Dahl, dahlimama inc
Production Manager: Kathleen Gaffney

Library of Congress Control Number: 2021946833

ISBN: 978-1-4197-5147-9
eISBN: 978-1-64700-571-9

Text copyright © 2022 Henry Carroll
Photograph credits on page 142
Image research: Kim Hungerford & Jack Harries (rafteditions.com)

Cover © 2022 Abrams
Front cover photograph: Courtesy of the artist, Clement Valla

Printed and bound in the United States
10 9 8 7 6 5 4 3 2 1

Abrams Image books are available at special discounts when purchased in
quantity for premiums and promotions as well as fundraising or educational
use. Special editions can also be created to specification. For details, contact
specialsales@abramsbooks.com or the address below.

Abrams Image® is a registered trademark of Harry N. Abrams, Inc.

ABRAMS The Art of Books
195 Broadway, New York, NY 10007
abramsbooks.com